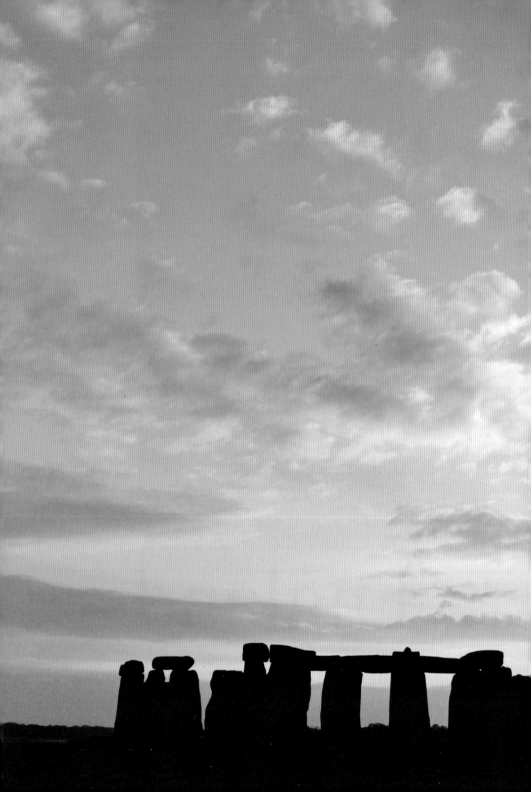

The pip travel photography guide to

England

photographers'
pip
institute press

First published 2006 by

© in the Work Photographers' Institute Press / PIP 2006

Photographers'
Institute Press / PIP

ISBN 1-86108-492-7 (10 digit)
ISBN 978-1-86108-492-7 (13 digit)

an imprint of
The Guild of Master
Craftsman Publications Ltd,
166 High Street, Lewes,
East Sussex BN7 1XU

Whilst every effort has been made to obtain permission
from the copyright holders for all material used in this
book, the publishers will be pleased to hear from anyone
who has not been appropriately acknowledged, and to make
the correction in future reprints.

The publishers can accept no legal responsibility for any
consequences arising from the application of information,
advice or instructions given in this publication.

British Cataloguing in Publication Data. A catalogue record of
this book is available from the British Library.

Production Manager: Hilary MacCallum
Managing Editor: Gerrie Purcell
Photography Books Editor: James Beattie
Editor: Virginia Brehaut
Managing Art Editor: Gilda Pacitti

Typeface: Meta Plus
Colour reproduction by Wyndeham Graphics
Printed by Hing Yip Printing Co Ltd

Contents

27

29

30

35

37

40

Foreword

When people talk of England any number of mental images are conjured, each of them different, but to the eye of the beholder as representative of this land as any other. For England is like a brand with a global reach of billions, popularized by both the iconic image on the postcard and the gentle past of a Victorian road less travelled.

Although England is not my country of birth, it is my home. In that respect I am like millions of others who have arrived, settled and offered a different perspective on the national identity of the country. Population growth and the changes it brings to the national infrastructure have placed new pressures on the landscape, directly affecting our view of this 'green and pleasant land'. New Towns, motorway expansions, housing developments, intensive farming and more recently wind farms are, for many of us, hideous blots on the landscape that threaten the romanticized idylls of Constable, Wordsworth, Elgar and Hardy.

It is these visions that most landscape photographers try to create through their lenses, sometimes with a judicious crop here to eliminate an unwanted electricity pylon and a touch of filtration there to add mood to the sky. Such actions are as valid as they are necessary because for every photographer it is the result that matters. The image is the message.

The PIP Travel Photography Guide to England is a companion to some of England's best known and most loved corners of landscape. From Derwentwater in the Lakes to Mousehole in Cornwall, the 41 locations photographed in this book offer the reader first hand advice about the myriad of subjects and angles available for a memorable day out with the camera. Written by the photographers who know these places as well as anyone, this compact handbook deserves to be as indispensable as your tripod when making your next foray to one of England's picturesque and inimitable corners.

Keith Wilson
Editor
Outdoor Photography

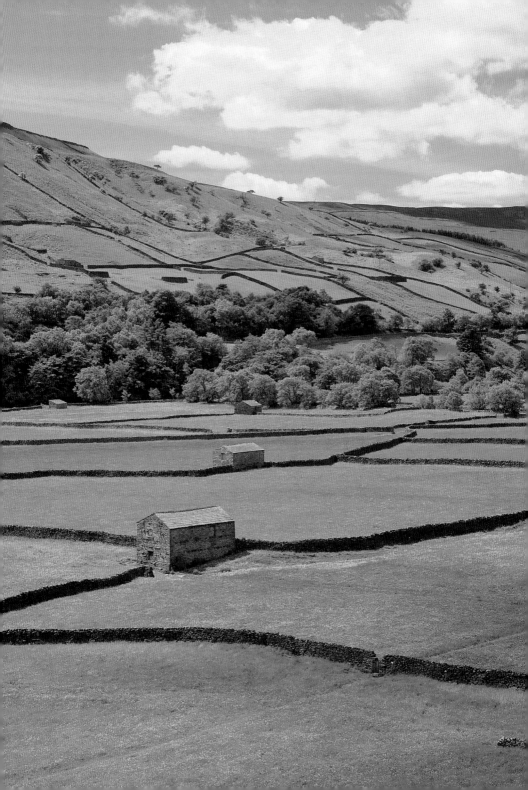

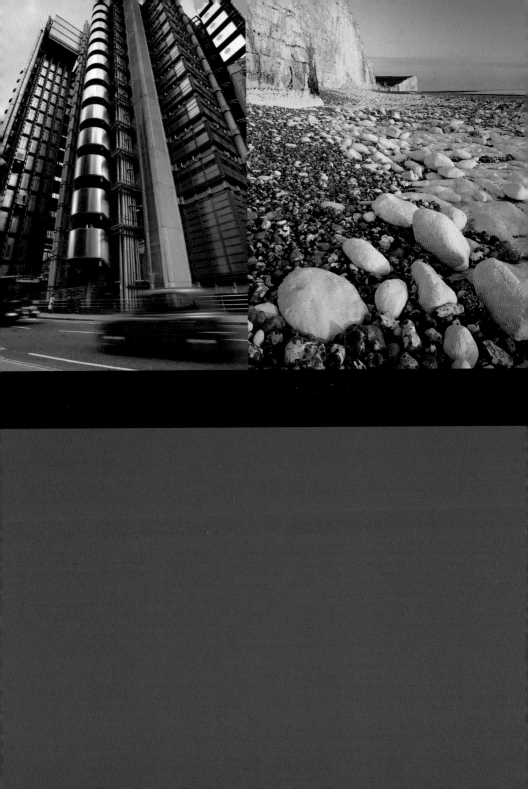

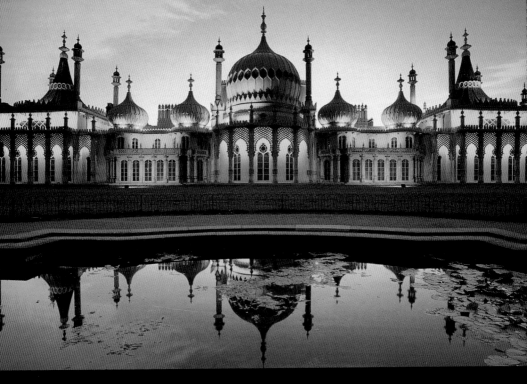

PART ONE **THE SOUTH & SOUTH-EAST**

LONDON IS SUCH A WELL-PHOTOGRAPHED CITY THAT YOU MIGHT
THINK THAT THERE IS LITTLE NEW TO DISCOVER, BUT IT IS ALWAYS
WORTH TAKING YOUR CAMERA ALONG **JAMES BEATTIE**

Obviously it is impossible to cover everything that
London offers so I've concentrated on just a few
of the more central sights that are easy to reach via
the comprehensive tube and bus network. One of the
best places to start is the south bank. Catch the tube
or train to London Bridge and walk up to the river
from where you can shoot Tower Bridge (which can
look very attractive at dusk, with the trails of light
from traffic streaming across it) and the Tower of
London. Walk westwards past the Millennium Bridge,
over which you can see the dome of St Paul's
Cathedral to the north. The building that houses the
Tate Modern was originally the Bankside Power
Station, and its modernist lines are extremely
imposing. Continuing west you can walk onto

Above Shooting at dusk
to capture the city lights
against a colourful sky is
a good way of making
London appear more
vibrant and dramatic.
*Canon EOS 1D Mark II
with 24–85mm lens,
1/8sec at f/22, ISO 400,
WB Auto, tripod*

London

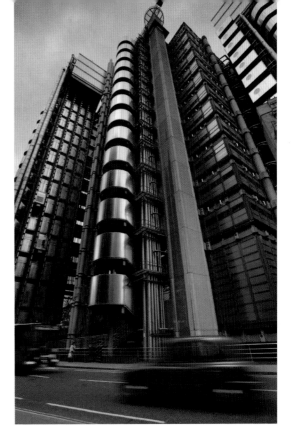

Right Waiting for a blue taxi cab and a red bus has added a splash of colour to this metallic grey shot of the Lloyds of London building, which was then tweaked using the curves function in Photoshop.
Kodak DCS Pro SLR/c with 17–40mm lens, 1/30sec at f/11, ISO 160, WB Auto, tripod

London

Established by the Romans in AD43 as a military camp, London went on to become the commercial and administrative centre of Roman Britain. Anglo-Saxon rule acceded to Norman rule with the victory of William the Conqueror, and London continued to grow over the following centuries despite setbacks, most notably in the form of the Black Death in 1348, the Great Plague in 1665 and the Great Fire of London in 1666. Victorian rule in the 19th century witnessed massive population growth as London became the hub of the world's largest empire. After the Second World War many Londoners left the city, creating a shortage of labour which was solved by large-scale immigration. It became the most ethnically diverse city in Europe resulting in today's varied and vibrant culture.

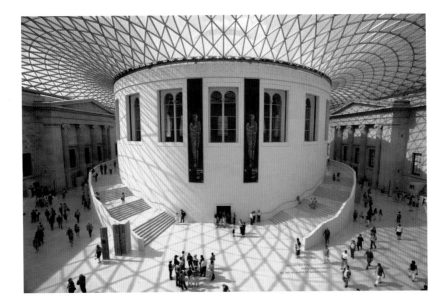

Above The impressive glass roof of the British Museum's Entry Hall. *Kodak DCS Pro SLR/c with 17–40mm lens, 1/125sec at f/11, ISO 160, WB Auto*

Blackfriars Bridge to capture images of the Oxo Tower, before walking on past London Bridge to view the Millennium Eye and, on Westminster Bridge, the Houses of Parliament and Big Ben.

North of the river, the City of London also offers plenty of photographic opportunities. Although its function as a world financial centre means it is less pleasant to wander around than many other parts of London, some of the buildings are incredible, most notably the Swiss Re Building (commonly known as the 'Erotic Gherkin') and the Lloyds Building, which Prince Charles said was a 'monstrous carbuncle'.

Another prime source of spectacular images is London's museums. Not only do they contain some fantastic exhibits, but the buildings that house them are equally impressive. Easily accessible from South Kensington Tube station are the Natural History Museum, the Victoria & Albert Musuem and the Science Museum. The British Museum is much more central, and has an incredible roof in the entry hall that is worth the visit alone.

PLANNING

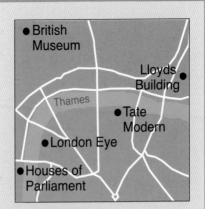

LOCATION
London is situated on the Thames Estuary in south-east England.

HOW TO GET THERE
London's major airports handle over 120 million passengers a year, while the Eurostar international terminal at Waterloo connects London to Europe via train. Within London a Travelcard will give you full use of the Tube, train and bus network. Most attractions lie within zones 1 to 4 and you can plan your route online at: http://journeyplanner.tfl.gov.uk

WHERE TO STAY
There are too many places to list here at an incredibly wide range of prices. The best websites are www.londonnet.co.uk for finding accommodation and www.timeout.com/london for hotel reviews.

WHAT TO SHOOT
There is masses to shoot in the whole city, but the south bank of the Thames is a good place to start. It offers the London Eye, views of the Houses of Parliament and Big Ben, Tower Bridge, the Tate Modern and much more.

WHAT TO TAKE
Versatile kit. A couple of zooms for framing in tricky situations, a sturdy tripod for low-light shots and a polarizer to saturate what can otherwise be slightly dull and muted colours. Restrictions on photography in museums normally only extend to a ban on tripods and monopods, but you should check websites before you visit.

BEST TIMES OF DAY
Any time, but probably mid-September as the crowds have thinned slightly from the height of summer and the school holidays have finished. A diary of events can be found at www.london.gov.uk

ORDNANCE SURVEY MAP
Landranger sheets 176 and 177

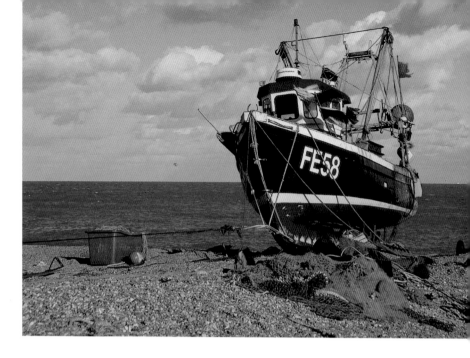

DOMINATED BY NUCLEAR POWER STATIONS, LIGHTHOUSES AND A STRETCH OF SHINGLE DOTTED WITH FISHING BOATS, DUNGENESS OFFERS SCENES OF FASCINATING BLEAKNESS **ANDREAS BYRNE**

The first time I visited Dungeness – a bare expanse of shingle on the south Kent coast, famed mainly for its nuclear power station – was on a fishing trip with my father and some of his friends. In the 20 years since that visit, Dungeness hasn't changed.

If this is your first foray to the area, you'll probably think you've made a wrong turn somewhere along the way and driven onto a 1950s sci-fi film set. The skyline is dominated by two large nuclear power stations – Dungeness A and B, which were completed in 1965 and 1983/5 respectively. They dwarf the little wooden bungalows and the two lighthouses, the older of which dates from 1904 and is no longer in service. The place looks like a desolate no-man's-land, until you look through a photographer's eyes – then pictures are to be found everywhere.

Above The low angle of afternoon sunlight in December gives a variety of changing colours and the old pier posts in the water can be used for foreground interest. The fish cages can just be seen in the left of the picture.
Minolta 600si with 28–105mm lens, exposure details not recorded, Velvia 50 polarizer, 81B warm-up filter, tripod

On the day I took the pictures here, the winter light was wonderful, the colours crisp and bright, and the shingle golden. I parked near the two lighthouses and tramped towards the fishing boats. Perched on top of a steep shingle bank, they are held in position by cables and winches. When the fishermen go to sea, they put down wooden sleepers which allow the boats to slide into the water. It is dramatic when the boats come back in as they speed up out of the sea and ram the shoreline, literally beaching themselves before being winched back up the shingle for the catch to be unloaded.

As with any scene, I first explored the beach for different angles and perspectives before taking any photographs. All the boats made appealing subjects in the winter sunshine, but boat FE58 had an interesting assortment of fishing paraphernalia around it, so I decided to compose a picture here, see main picture opposite.

I set up my tripod with my Minolta 600si and a 28–105mm lens. A polarizer enhanced the colours

Below I had put away my camera as the weather had clouded over, when I spotted this boat. All of a sudden there was a break in the clouds. It was then a rush to set up my camera gear in time. I took a few frames before the sun disappeared again.
Minolta 600si with 175–500mm lens, 1/125sec at f/6.7, Velvia 50

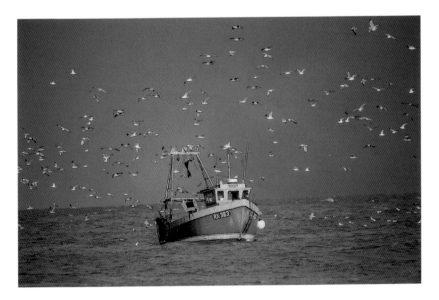

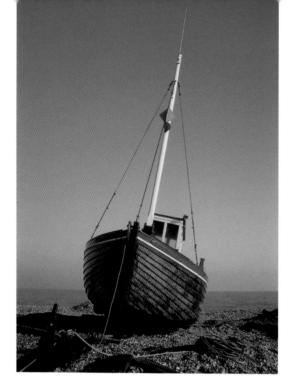

Left I felt the portrait format suited this boat, which is set further down the beach and called *Moonraker*. A polarizer and 81B warm-up filter enhanced the colour.
Ricoh KR10 with 28mm lens, 1/2sec at f/22, Velvia 50, polarizer, 81B warm-up filter

and took away any reflections, even though I wasn't at quite 90 degrees to the sun. The polarizer also had the effect of deepening the blue sky, which was looking increasingly impressive, as some clouds had started to appear. I then added an 81B warm-up filter, which mellowed the whole scene.

Dungeness

Dungeness has the largest continuous area of shingle in Britain and, over the years, it has been home to five lighthouses. The first was erected by Sir Edward Howard in 1615, but had to be pulled down at a later date as the sea had receded, leaving the lighthouse stranded inland. You can visit the old lighthouse of 1904 and climb the 169 steps to the giant lens at the top. Dungeness has two very large nuclear reactors, which dominate the flat, bleak landscape.

PLANNING

LOCATION
Dungeness is in south Kent.

HOW TO GET THERE
From London, follow the M20 and take the Junction 10 exit onto the A2070 to Brenzett, followed by the A259 to New Romney. Turn off the A259 onto the B2075, following directions for Lydd. Dungeness is signposted from Lydd. From Rye, take the A259 and follow the same directions from New Romney.

WHERE TO STAY
The nearest Tourist Information Centre to Dungeness is in Rye, and is open all year round, tel: +44 (0) 1797 226696. Alternatively, go to www.visitsoutheastengland.com

WHAT TO SHOOT
The main attractions for me are the fishing boats, but you can shoot the nuclear power station, which is best at dawn or dusk, as it's lit up. The lighthouses, interesting wooden houses, a fisherman digging for bait, macro shots of peeling paint, or ropes and other fishing tackle.

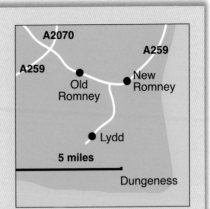

WHAT TO TAKE
As it is usually windy at Dungeness, all forms of warm clothing, including thermals, fingerless gloves and a hat. Wellington boots are useful if you wish to walk onto the beach. Pack your bag with plenty of film and a variety of lenses. Polarizing, warm-up and neutral-density graduated filters are useful.

BEST TIMES OF YEAR
During the spring and summer months, there is a variety of flowers to photograph, including clumps of sea kale, dwarf broom, thrift, yellow horned poppy and the rare Nottingham catch fly.

ORDNANCE SURVEY MAP
Landranger sheet 189

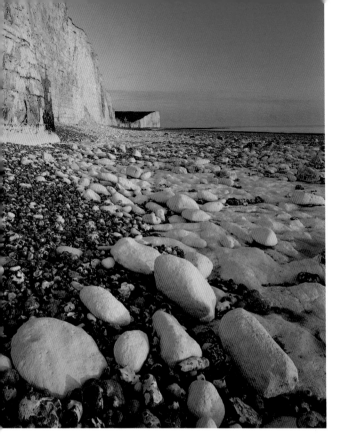

Left I selected this grouping of boulders and closed in with a wideangle lens to make this a picture where the foreground is the dominating feature. It was taken during the last seconds of sunlight before sunset.
Mamiya RZ67 with 50mm lens, 1sec at f/22, Velvia 50, polarizer, tripod

WHERE THE CHALKY SOUTH DOWNS MEET THE SEA, THESE DRAMATIC WHITE CLIFFS STAND PROUD AS ONE OF THE MOST STRIKING SIGHTS IN THE SOUTH-EAST **DEREK CROUCHER**

The Seven Sisters

The undulating chalk cliffs of the Seven Sisters rate as one of the country's truly dramatic scenic areas. Which is a fact I'm quite pleased about, living down in the south-east corner, and usually having to travel some distance west or north to search out the best landscapes. So I'll often find myself heading in this direction in the winter months, where the striking coastal scenery can look its best at any time of year, providing there is good light. Other places to visit in the area are Beachy Head Lighthouse and the Cuckmere River, both make great subjects.

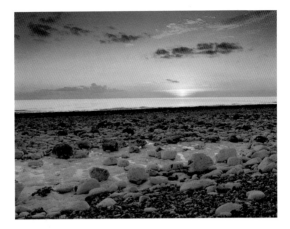

Right After sunset, I turned the camera out to sea. Just a minute or two later, but see the colour change on the rocks. A strong neutral-density graduated filter is needed to prevent the foreground from becoming black.
Mamiya RZ67 with 65mm lens, 1/2sec at f/22, Velvia 50, neutral-density graduated filter, tripod

There is a whole variety of possible shooting positions in the area, either from the clifftop or down below. For these shots, I accessed the beach using the steps at Birling Gap – a point roughly half way between Beachy Head and the Cuckmere River, and since the tide was well out there was scope for a variety of different angles.

The main composition I had in mind at this time was a shot looking along the cliff from near the top of the beach, using some rocks or sand in the foreground. I also wanted to shoot just before sunset so the lighting had a soft, warm quality. This can only

FACTS ABOUT:

The Seven Sisters

The Seven Sisters are part of the chalk cliffs formed where the South Downs meet the English Channel, between Seaford and Eastbourne. The power of the sea at places like this is startling. The constant erosion of the cliff threatens any building close to the edge. A few years ago, the original clifftop lighthouse – now converted for residential use – had to be severed from its foundations, lifted by cranes and dragged back from the edge, to save it from the inevitable fall off the cliff edge.

be done in winter, since in summer the sun sets inland and the cliffs would be in shade. But the mistake I made the first time around was to visit on a warm sunny weekend. Getting a shot without footprints in the sand or people in the frame proved to be almost impossible. Each time I lined up a composition and the light was just right, someone would walk along the beach. But of course, my frustration had to be turned inward, since they had just as much right to be there as I did.

Next time, I chose a weekday and had the beach to myself. I had time to enjoy the sounds of the sea and the strange feel of the softness of the chalk boulders under my feet. The fading light gradually turned orange and pink and I carefully and calmly took all the shots I wanted. The enjoyment of being there is as important as the photography itself.

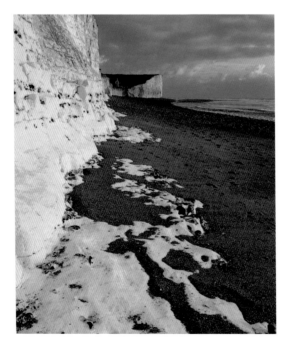

Left Notice the bands of flintstones running through the chalk at regular intervals. I was happy with the composition, but footprints in the sand and people in the distance prompted me to return on a quieter day. *Mamiya RZ67 with 50mm lens, 1/2sec at f/22, Velvia 50, polarizer, tripod*

PLANNING

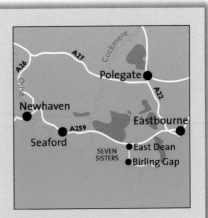

LOCATION
On the East Sussex coast about 4 miles (6.4km) west of Eastbourne.

HOW TO GET THERE
Use the A259 Seaford to Eastbourne road and turn off at East Dean for the Birling Gap car park. For an excellent view of the whole range, use the car park west of the Cuckmere River, accessed via the outskirts of Seaford.

WHERE TO STAY
There are plenty of accommodation choices in nearby Eastbourne. For full listings contact the local Tourist Information Office, tel: +44 (0) 1323 415450, or go to www.visitsoutheastengland.com

WHAT TO SHOOT
There are many angles from which to shoot the cliffs – pebbles, chalk boulders and sand make the best foregrounds, and if the tide is just below its highest level some crashing waves would look great. Beachy Head Lighthouse and the meandering Cuckmere River also both make great subjects.

WHAT TO TAKE
Your usual lens range for landscapes would be fine. If it's windy, a cloth to wipe off the salt spray. And good strong boots are essential as the walking can be very uneven.

BEST TIMES OF YEAR
Undoubtedly in winter, since the cliffs always look the same, and the low winter light out to sea is ideal.

ORDNANCE SURVEY MAP
Landranger sheet 199

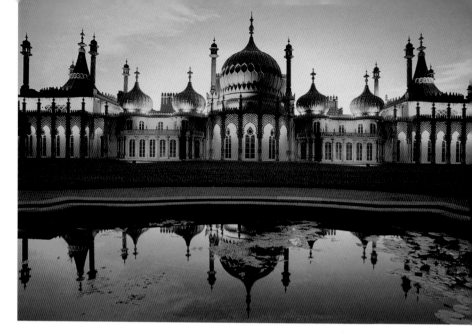

A UNIQUE TESTAMENT TO THE ECCENTRICITIES OF THE PRINCE REGENT, THE ROYAL PAVILION DRAWS MANY VISITORS, AS DO THE OTHER CHARMS OF THIS GRAND SEASIDE TOWN **STEVE DAY**

Above Don't be fooled – there's no lake in front of the Pavilion, just a small pond that has been exaggerated by a wideangle lens. *Canon EOS 50E with 20–35mm lens, 1/2sec at f/16, Velvia 50, tripod*

Brighton's Royal Pavilion is a mish-mash of styles typical of a Western misinterpretation of Oriental architecture, incorporating elements from Indian, Chinese and Thai design. All rather tasteless and excessive – a wonderful subject for photography.

A central viewpoint is best because the building can be shown reflected in the water. Don't be led astray by the picture above (which appears to show a large lake) as this is a classic example of the camera lying – it's a small pond which a 20mm wideangle lens has made the most of. The wideangle was necessary anyway because it's impossible to step back further from the building without being mown down by Brighton's utterly appalling traffic.

The main advantage of the Pavilion is that there is so much to explore. The building is interesting from any angle so, no matter what time of the day you're

there, there's always something to photograph, and there is so much detail in the design that there is plenty of scope for abstract shots, or little cameos.

Just for a change I don't advocate getting up very early – the palace is too shaded for photography in the first and last hours of the of the day, but early and late light is worth catching as it gives a mellow warmth to the building.

Explore the rest of the town – there's so much to photograph. The crumbling, romantic ruin of the West Pier is a fascinating subject as is the Brighton Pier. The Victorian architecture on the promenade between the two piers is well worth photographing, especially during late afternoon when the sun is low, and a stroll back along the beach is fun, as it's typical of many British seaside resorts, with a colourful mix of brightly painted funfair rides, primary-coloured beach umbrellas and the odd boat or two.

Expert Advice

The classic view of Brighton Pavilion is naturally from the front, but as this faces east the lighting is always rather flat.

As a result, it is better to photograph it at dusk when the artificial lighting is turned on, and there's still some light in the sky.

FACTS ABOUT:

The Royal Pavilion, Brighton

The Pavilion was originally a stone farmhouse used by the Prince of Wales for 'fun and games' away from the Royal Court. In 1787 he had it converted into a Palladian villa, which satisfied him for around 20 years, but he then decided that a complete transformation was needed. He already had a taste for Chinese decoration and when he commissioned the architect John Nash to come up with a new building, Nash totally redesigned it, creating the glorious mixture of 'Oriental' domes, balconies and pagodas that make the building such a fascinating subject. Though Queen Victoria subsequently used the building, she eventually ordered it to be stripped of its contents and the shell sold. The Pavilion then passed through various owners as a concert hall, tearooms and a hospital, but it has now been restored to its original glory – the inside is well worth exploring.

Right The Victorian architecture, when shot in the right light, is highly photogenic, as this little booth on the Brighton Pier shows. *Canon EOS 50E with 20–35mm lens, 1/2sec at f/16, Velvia 50, polarizer, tripod*

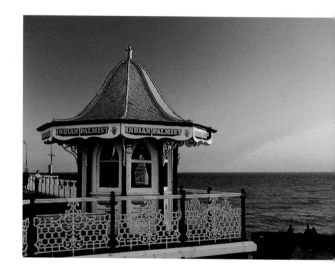

Below Against-the-light shots aren't difficult, and usually produce dramatic results as the scene is reduced to silhouettes and highlights. A reading was taken from the foreground pavement and the sun was carefully excluded from the picture. *Canon EOS 50E with 28–105mm lens, 1/60sec at f/16, Velvia 50, tripod*

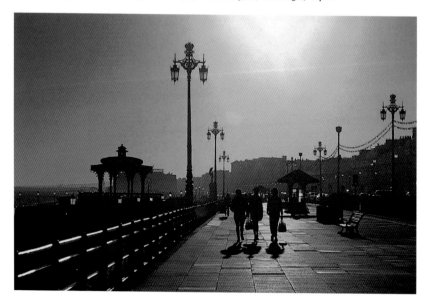

PLANNING

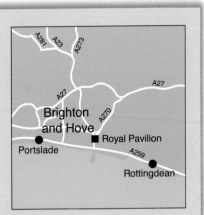

LOCATION
Brighton is on the south coast in East Sussex, and the Royal Pavilion is well signposted. It's just inland of the Brighton Pier.

HOW TO GET THERE
Trains from London Victoria, King's Cross or London Bridge, or the A23 from London or the A27 coast road.

WHERE TO STAY
The Lanes is the place to go for food – you'll be spoilt for choice. There you can find a complete range of food and drink, and a wide choice both in terms of type and price. For full listings of accommodation contact the local Tourist Information Office, tel: +44 (0) 0906 711 2255, or go to www.visitbrighton.com

WHAT TO SHOOT
Brighton is a typical traditional Victorian seaside resort in terms of architecture and beach attractions, but is surprisingly diverse and full of life away from the beach.

WHAT TO TAKE
The normal range of kit.

BEST TIMES OF YEAR
The town is interesting throughout the whole year, and the piers make excellent winter subjects, but spring to autumn is best for beach and street life.

ORDNANCE SURVEY MAP
Landranger sheet 198

The New Forest

POCKETS OF ANCIENT WOODLAND NESTLE INTO GREAT CARPETS OF HEATHLAND INHABITED BY WILD PONIES AND DEER, MAKING THE NEW FOREST AN ENCHANTING DESTINATION **COLIN VARNDELL**

The New Forest is peppered throughout with photogenic oak and beech woods, but my own favourite areas for photography are the Bolderwood and Rheinfield ornamental drives which run north and south of the A35 between Lyndhurst and Christchurch. The Rheinfield ornamental drive is principally an arboretum with impressive North American redwoods lining the forest road. Bolderwood is made up of ancient beech woods dotted with plantations of conifer and hardwoods.

Below The wild deer of the forest are most active during the rutting season. Fallow and red deer can be encountered just about anywhere but the most reliable photographic opportunities occur at the Bolderwood Deer Sanctuary. Here the deer are free to come and go while humans are restricted by fences. *Nikon FM with 500mm lens, 1/250sec at f/4, Kodachrome 200*

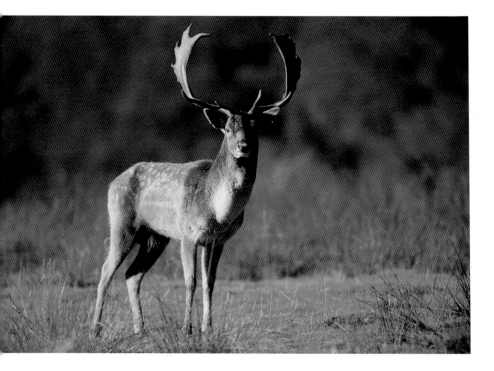

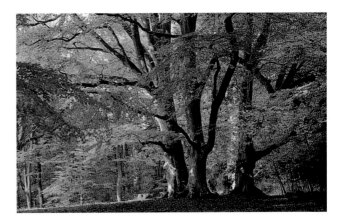

Right Even in the remarkably beautiful location of the New Forest finding good compositions which fit the rectangular format is not easy. Simplicity is the key, but searching for it takes a lot of legwork. Once I have found a scene that suits my choice of composition I tend to return and photograph it in all seasons. These three beech trees stand at the edge of the forest road along the Bolderwood Ornamental Drive, and were crying out to be photographed. An 81C warm-up filter was added here to intensify the autumn colours.
Nikon FE2 with 24mm lens, 1/30sec at f/11, 81C warm-up filter

This was once managed woodland and the beeches were pollarded to encourage growth of straight branches for use by the Royal Navy. Sadly many of these magnificent trees were lost in the storms of the 1980s, but the few that remain offer a wealth of photographic potential.

The beech woods are at their most colourful from late October to mid-November when the deciduous leaves change from summer green to vibrant yellow. This golden stage lasts for only a few days before the colours fade to deep rust prior to leaf fall.

Capturing the atmosphere of woodland in autumn can be one of the most rewarding challenges in nature's annual cycle. At this time of year I particularly like to photograph woodland scenes in wet weather. When rain coincides with that brief stage of autumn gold the effect can be sheer magic. Thick rain cloud acts as a massive diffuser, eliminating shadow. Raindrops saturate the foliage, enriching the warm, autumn colours and the wet trunks darken to contrast with the bright leaf colour.

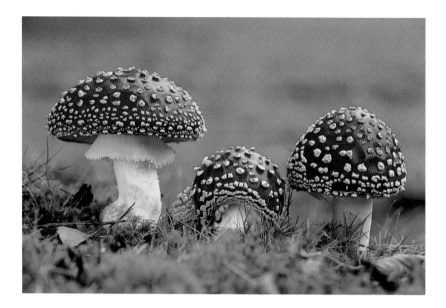

Above The ancient trees and abundance of dead wood are perfect hunting grounds for fungi pictures. I think the most photogenic is the fly agaric, which thrives on the dead roots of silver birch. The silver birch is a naturally predominant species of the forest so these speckled crimson toadstools are often plentiful in autumn. The white specks on the cap are the shrivelled remains of a veil which protects the fruiting body as it pushes up through the earth.

Nikon FE2 with 100mm lens, 1/30sec at f/11, Kodachrome 64

FACTS ABOUT:

The New Forest

The New Forest in Hampshire falls within a rough triangle between the towns of Salisbury, Bournemouth and Southampton. It is the largest tract of lowland forest in Britain. The landscape comprizes of three main habitats: lowland heath, conifer plantations and mature broad-leaved woodland. Together with valley bogs, agricultural land and amenity areas these habitats support a greater range of flora and fauna than any other single location in Britain.

PLANNING

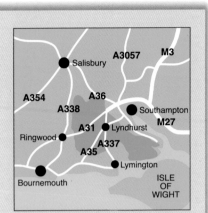

LOCATION

The New Forest is in Hampshire between Bournemouth and Southampton. The A31 trunk road cuts across the middle of the forest.

HOW TO GET THERE

From London take the M3 and join the M27 westbound. At the end of the motorway take the A337 to Lyndhurst. A car is ideal for moving between locations within the forest but overnight camping is not permitted in the forest car parks.

WHERE TO STAY

There are official campsites in the forest. Contact Tourist Information, details below, for full listings. Some recommended hotels are:
The Cloud Hotel,
tel: +44 (0) 1590 622165,
www.cloudhotel.co.uk
Knightwood Lodge Hotel,
tel: +44 (0) 2380 282502,
www.knightwoodlodge.co.uk
The New Forest Tourist Information Centre can provide up to date accommodation lists,
tel: +44 (0) 2380 284404. Or go to www.visitnewforest.com

WHAT TO SHOOT

In autumn, beech trees, deer, fungi and forest ponies. I also like the spring when the beech trees burst into life with fresh green foliage.

WHAT TO TAKE

The main problem when shooting in rain is keeping the equipment dry. Changing lenses or film can be tricky, so in wet conditions I prefer to use a large golfing umbrella. Working from a shoulder bag I can stand at the tripod with the bag open and everything is protected by the umbrella. The beech woods are often extremely boggy in places so it is advisable to wear wellington boots.

ORDNANCE SURVEY MAP

Landranger sheets 195 and 196

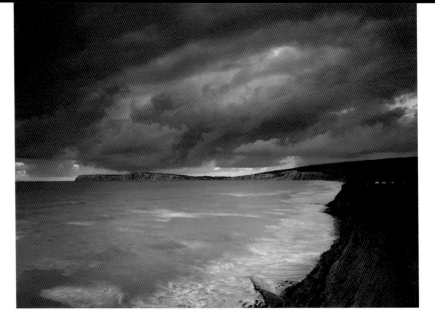

FAVOURITE COUNTRY RETREAT OF QUEEN VICTORIA AND SAILING HEAVEN, THERE IS MUCH TO DISCOVER ON THE ISLE OF WIGHT, INCLUDING WONDERFULLY UNSPOILT COASTLINE **RON LILLEY**

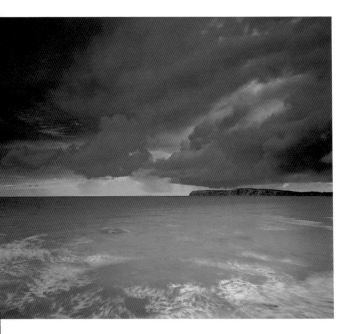

Left Dusk, Compton Bay. I decided on four seconds at f/22 to produce ominous looking clouds. The first sheet was push processed to ISO 100. The picture was too dark, so the second sheet was pushed by two stops to ISO 200. *Toyo field 5 x 4in with 90mm lens, 4secs at f/22, Velvia 50, 3-stop neutral-density graduated filter, tripod*

Left Sunset, Compton Bay. This was taken from Hanover Point at the southern end of Compton Bay, looking north-west to Tennyson Down. *Toyo field 5x4in with 90mm lens, 4secs at f/16, Velvia 50 rated at ISO 100, 3-stop neutral-density graduated filter*

March is a pleasant month on the southern side of the Isle of Wight. With the cold weather finally improving, and the tourist season not yet underway, the coastal paths are quiet and peaceful and the roads are less congested.

Compton Bay is a popular haunt for summer tourists, offering a beautiful, clean, sandy beach sitting between Freshwater Bay and Brook on the main coast road. Alum Bay offers a backdrop of towering cliffs and the extra photographic opportunity of coloured sands. Take the steps and a chairlift to the Pleasure Park, and you will find breathtaking views of the Needles rocks and lighthouse.

Below Compton Bay. This was taken in March 1997, on an unusually mild day. The sea was a lovely colour and the shot benefited from a polarizing filter to enhance the colour of the sky and the sea. The filter removed the slight glare from the surface. *Mamiya RB67 with 65mm lens, 1/125sec at f/22, Velvia 50, polarizer, tripod*

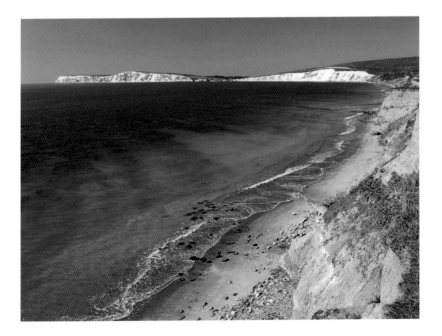

Compton Bay

Situated on the south-west side of the Isle of Wight, Compton Bay stretches from Hanover Point in the south-east for 2¼ miles (3.6km) to Freshwater Bay in the north-west. The majority of the coast at Compton Bay belongs to the National Trust. The southern coast is well known for its importance in palaeontology – the study of fossils. At Hanover Point, there lies the remains of a fossil forest, and pieces of fossilized wood can be found at low tide. The area is also one of the few places where the Glanville fritillary butterfly can be found – they are reported to be in decline. In the past I have seen the larvae in large numbers both here, and at other locations on the Isle of Wight. The larvae can be seen feeding on ribwort plantain in March and April. The adults can often be spotted in June.

Expert Advice

The Isle of Wight offers an extremely varied coastline, spanning some 60 miles (100km) and including chalk and sandstone cliffs, sandy shores, marshes, river estuaries and saltings – areas of low ground regularly inundated with salt water. For me, the south-west section of the island – Compton Bay to Alum Bay – is particularly picturesque, and provides the perfect opportunity for some great photographs.

Around half of the Isle of Wight is designated as an Area of Outstanding Natural Beauty, and nearly 30 miles (45km) is Heritage Coast – a designation applied to high-quality, unspoilt coastlines in England and Wales. Compton Bay comes under both headings.

These three pictures were all taken from Hanover Point, at the southern end of Compton Bay, looking north-west to Tennyson Down. I had decided that the best position for the setting sun would be to the left of the distant headland. This headland – Tennyson Down and West High Down – has its tip at 275 degrees. I chose 21st March as the perfect day, as this is the date of the vernal equinox – the time at which the sun crosses the plane of the equator towards the relevant hemisphere, and sets at 270 degrees. The main picture, on page 32, was taken at 6.10pm Greenwich Mean Time, about ten minutes before sunset. I was lucky to be met with cloud formations as broken cloud always improves sunsets and sunrises. This view can be photographed at any time of year but I prefer March at sunset with a high tide.

PLANNING

LOCATION
Compton Bay lies on the south-west of the Isle of Wight.

HOW TO GET THERE
Car and passenger ferries run from various ports on the south coast of the mainland, run by Wightlink Ferries, tel: 0870 582 7744 (from UK), +44 239 285 5230 (from overseas). Or visit their website at www.wightlink.co.uk
Bus services are run by Southern Vectis, tel: +44 (0) 1983 532373, www.svoc.co.uk
By car from Freshwater Bay, take the A3055 east for about 2.5 miles (4km) to Hanover Point where there is a car park. There is also a bus service that stops here. From the car park it is a short walk west to the viewpoint.

WHERE TO STAY
There are several hotels in Freshwater Bay. The nearest campsite is Grange Farm, tel: +44 (0) 1983 740296, about four miles (6.4km) south-east of Hanover Point. For full listings contact the Isle of Wight Tourist Information Office, tel: +44 (0) 1983 813818 or go to www.isleofwight.com

WHAT TO SHOOT
Compton Bay coastline, Freshwater Bay viewed from the east. Coastal views from Afton Down. To the west of Freshwater Bay lies Tennyson Down and the Needles.

WHAT TO TAKE
Tripod, wideangle lens.

BEST TIMES OF DAY
Late afternoon and around sunset.

ORDNANCE SURVEY MAP
Landranger sheet 196

PART TWO THE SOUTH-WEST

Durdle Door

ON DORSET'S ANCIENT JURASSIC COAST STANDS DURDLE DOOR, A SUPERB EXAMPLE OF THE GEOLOGICAL IMPORTANCE OF THIS AREA CHARMING LULWORTH COVE NESTLES NEARBY **DEREK CROUCHER**

This is a fascinating area, with miles of spectacular coastal scenery, and is justifiably popular with walkers. The spectacular nature of the scenery stems from the varied geology and is ideal for photography.

I had long wanted to try working in panoramic format having long admired shots by the likes of Colin Prior and Nick Meers, but always being concerned whether I could make the investment in hardware pay off in the long term. The cost of a dedicated panoramic camera plus two or three lenses is considerable, so when a friend suggested he sell me his 6 x 12cm film back which would fit onto my existing large format system, I jumped at the chance.

Below Blue sky and warm evening light has made the coolness of the water contrast with the pebbles. I timed the long exposure to give this effect as a wave receded. *Linhof Technikardan with 6 x 12 film back, 120mm lens, 4secs at f/22, Velvia 50, polarizer, 3-stop neutral-density graduated filter*

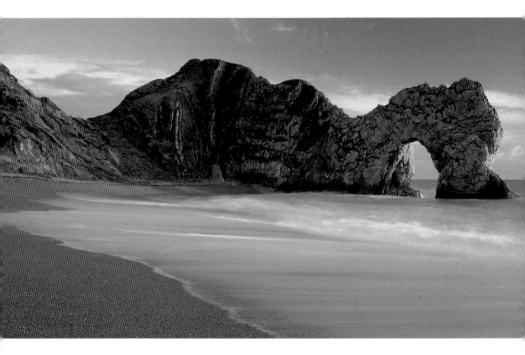

Expert Advice

Although the aspect ratio of the 6 x 12 format, at 1:2, is not as extreme as a 6 x 17cm camera, my experience with it has been nothing but positive – every subject I come across seems to fit it. When I saw the results, it seemed that a simple piece of hardware had opened up a whole new area of creativity.

One of the first locations where I chose to try out the 'letter box' approach was the superb Durdle Door. I had a number of coastal locations I wanted to visit during late afternoon sunlight so I waited until there was a decent weather forecast and headed for Dorset, where the beach would be partly exposed and the waves on the retreat.

The most scenic approach to Durdle Door is from Lulworth, but with my heavy backpack I chose the nearer car park off the side road, which happens to be adjacent to a very large caravan site. However, you soon lose this behind and are greeted by superb views of, first, St Oswald's Bay, then Durdle Door with Swyre Head and Bat's Head beyond.

On this occasion the natural elements all worked in my favour – the waves were just right, and once the cloud had gone, the afternoon sunlight was unusually clear. The main problem I did encounter was other

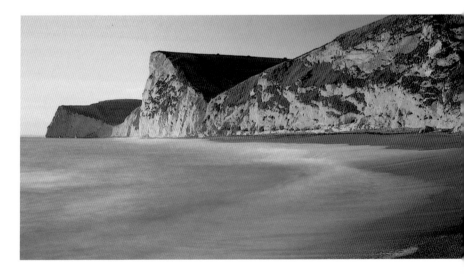

Above The undulating chalk downs create some superb geometric shapes where they meet the sea. This is Bat's Head and Swyre Head from near Durdle Door.
Linhof Technikardan with 6 x 12 film back, 120mm lens, 4secs at f/16, Velvia 50, polarizer, 3-stop and 1-stop neutral-density graduated filters

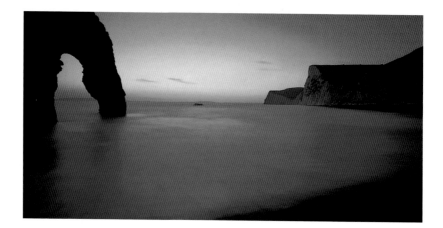

Above I stayed till after sunset and used an extreme wideangle for this shot. Provia coped with the long exposure. *Linhof Technikardan with 6 x 12 film back, 65mm lens, 30secs at f/32, Provia 100, 3-stop and 1-stop neutral-density graduated filters, 81C warm-up filter*

people walking along the beach – certainly not something I can complain about so I'll not make any comment here, though perhaps I did mutter something under my breath at the time.

Luckily, as the sun got lower towards evening, the people began to move off home and I was left with the beach to myself. I waited for a wave to create a nicely defined edge, then started the four-second exposure to capture the streaking effect as the water retreated over the pebbles. I had time to try a few different angles and lenses, and stayed till after sunset to watch the afterglow reflecting in the sea.

FACTS ABOUT:

Durdle Door

Rock strata originally laid down horizontally have been turned on end to form vertical bands which can clearly be seen at Durdle Door. The arch itself is made of limestone from the Jurassic Era, and is resistant to erosion. The rocks to the landward side are weaker clays and have been eroded faster, giving rise to the natural bay here and the spectacular Lulworth Cove nearby. In various places holes can be seen in the rock – these are the cavities left by the rotted wood of Jurassic trees.

PLANNING

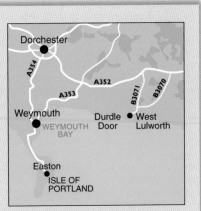

LOCATION
On the Dorset coast about a mile (1.6km) west of West Lulworth.

HOW TO GET THERE
Using the A352 Wareham to Dorchester road, turn onto the B3071 for West Lulworth. In West Lulworth either turn right for the signed Durdle Door car park, or park near Lulworth Cove and walk along the clifftop.

WHERE TO STAY
The Castle Inn at West Lulworth has B&B accommodation, tel: +44 (0) 1929 400311, www.thecastleinn-lulworthcove.co.uk
For other ideas go to www.visitsouthwest.co.uk

WHAT TO SHOOT
There are numerous possibilities along this coast – concentrate on the cliffs and beaches.

Try experimenting with long exposure times on the waves. For more information about the area go to www.jurassiccoast.com

WHAT TO TAKE
Salt spray can be a problem, so take a good lens cloth and keep checking the lens.

ORDNANCE SURVEY MAP
Landranger sheet 194

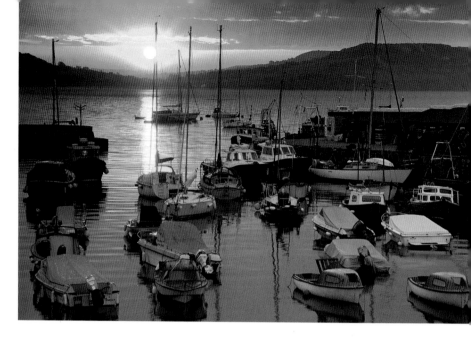

SET ON THE BORDER OF THE CAPTIVATING COASTLINE OF DORSET AND DEVON, PICTURESQUE LYME REGIS HAS BEEN A POPULAR COASTAL RESORT FOR CENTURIES **GUY EDWARDES**

Often referred to as 'the pearl of Dorset', Lyme Regis is an unspoilt seaside town and fishing port situated on the historic Cobb Harbour overlooking Lyme Bay. It is a great location for a summer family vacation as normal holiday activities can easily be combined with photography and it isn't necessary to travel far to find good locations.

During one early morning visit to Lyme Regis harbour I noticed that the sun was rising almost centrally in a dip in the distant hills to the east. I saw the potential for a very nice composition overlooking the harbour. Unfortunately, the light on that particular morning wasn't very interesting, and I needed to return three times before I finally got a good shot. The raised viewpoint of the sea wall gave me a clear view over the harbour and provided better separation of the boats within it.

Above This view across Lyme Regis harbour was taken at just after 5am in early July. Only at this time of the year does the sun rise centrally between the hills to the east. It was important to shoot before the sun rose above the early morning haze and became too bright to look at.
Canon EOS 3 with 28–70mm lens, 1/2sec at f/16, Velvia 50, 2-stop neutral-density graduated filter, tripod

The ancient curving Cobb wall, which stretches into Lyme Bay, not only provides an interesting subject in itself but also a useful raised viewpoint from which to survey the magnificent west Dorset coastline. During rough weather huge waves lash the Cobb. Walking along the wall can be very dangerous at times like this, but spectacular photos are possible from a safe distance. At high tide, enormous waves often crash into the sea wall directly below the town.

To the west of the town is the famous Undercliff National Nature Reserve – an area of dramatic landslips running down to the sea, where deep chasms and inaccessible slopes form a haven for wildlife. Access to this area is restricted to a public footpath as the slips can be hazardous during and after wet weather. Wild flowers abound here, especially in early summer. To the east of Lyme the bay sweeps around to Black Ven – an area of particularly active landslips that creates a dramatic and ever-changing coastline. It is possible to walk

Below The Cobb dates back to the 13th century and although it has undergone countless alterations over the years, its primary purpose has always been to shelter the harbour and seafront from the full force of Atlantic gales. It provides a great vantage point from which to view Lyme Regis and the stunning Dorset coast. *Canon EOS 3 with 24mm lens, exposure details not recorded, Velvia 50, 2-stop neutral-density graduated filter, tripod*

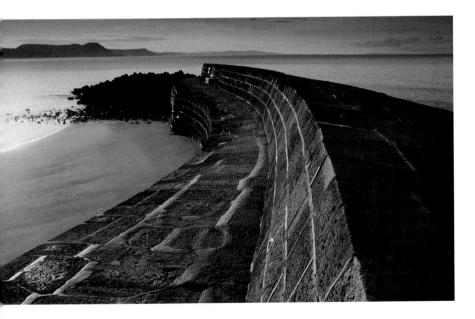

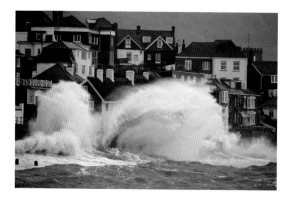

Left Storms frequently
batter the coast around
Lyme Regis. The harbour
wall protects the town
from south-westerly
gales but, when a south-
easterly blows, huge
waves often hammer the
seafront. It is possible to
shoot dramatic images
from a safe distance, but
be warned that your gear
will get a good coating of
salt spray.
*Canon EOS 5 with
100–400mm lens,
1/125sec at f/5.6,
Provia 400, tripod*

between Lyme Regis and nearby Charmouth at low tide. There are numerous rock pools exposed at low tide that exhibit a variety of colourful marine life, while the more stable cliffs and mudflows are home to colourful displays of wild flowers.

From below Black Ven there are great views along the coast towards Golden Cap, with plenty of large boulders that can be used for foreground interest. On the cliffs and along the shoreline fascinating geology provides possibilities for interesting close-up shots, as well as abstract landscapes. The weather along the coast can be very unpredictable and conditions can change rapidly, so never give up until you're sure the chances of good light have gone for the day.

FACTS ABOUT:

Lyme Regis

Surrounded by beautiful coastline and countryside, this area is part of the recently designated Jurassic Coast World Heritage Site and is famous for its geology and fossils. The River Lym flows gently through the heart of the town where you will find small shops, galleries, studios, cafes and pubs in a mosaic of narrow, winding streets rising steeply from the sea. The town and harbour are famous as the set for the film *The French Lieutenant's Woman*, starring Meryl Streep and Jeremy Irons.

PLANNING

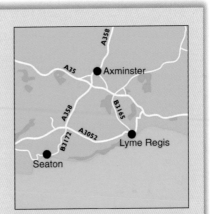

LOCATION
Lyme Regis is in south-west Dorset, close to the border with Devon.

HOW TO GET THERE
From the A35 turn south onto the A3052 into the town.

WHERE TO STAY
There are plenty of hotels and guesthouses. Lyme Regis gets very busy during summer so it is best to find accommodation in the town as the harbour is a short walk away. For listings and information try www.lymeregistourism.co.uk or www.visitsouthwest.co.uk

WHAT TO SHOOT
Most obvious is the harbour with its colourful boats and ancient sea wall. To the east and west of the town are promontories with rock pools and sand that provide the perfect foreground to coastal landscapes at sunrise and sunset. Nearby Charmouth is great for coastal landscapes.

WHAT TO TAKE
A full range of photographic equipment can be used around Lyme Regis and the accessibility of many of the locations means that weight need not be an issue.

BEST TIMES OF YEAR
For the best range of subjects visit during the summer. Between late May and late September the harbour is filled with colourful boats and the coastline provides a great display of wild flowers. However, the town can become very busy at this time of year. Early morning provides the best light.

ORDNANCE SURVEY MAP
Landranger sheet 193

DARTMOOR NATIONAL PARK IS A RUGGED PATCHWORK OF MOORLAND PACKED WITH WILD, CRAGGY SCENERY AND REMARKABLE ARCHAEOLOGICAL SITES **LEE FROST**

If you scare easily, don't go to Dartmoor. I've travelled the length and breadth of the UK and walked thousands of miles alone, in search of great landscape pictures, but the only place I've ever felt uneasy is Dartmoor. Maybe I've read one too many books about the goblins, witches, hairy hands and headless hounds that are said to haunt the moors. Perhaps it's the emptiness and isolation you sense when the cloud base comes down or the sun begins to set and you realize there's no one else around.

I may be exaggerating things a little, but one thing is for certain – Dartmoor's a magical, mysterious place and in the right kind of weather and light it's one of the most amazing locations for landscape photography you're likely to find anywhere. If I were to nominate some must-see spots on Dartmoor, Hound Tor would be in the top five. As well as being big and bold compared with many of the tors, there's

Below Nothing brings out the drama and rugged beauty of Dartmoor better than a stormy day, but be prepared to get wet. This shot was taken in mid-afternoon – I composed the scene then waited for the light to break and illuminate the foreground.

Horsesman Woodman 5 x 4in field camera with 90mm lens, 1/2sec at f/32, Velvia 50, 2-stop neutral-density graduated filter, 81B warm-up filter, tripod

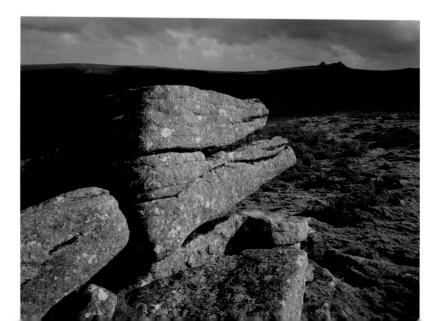

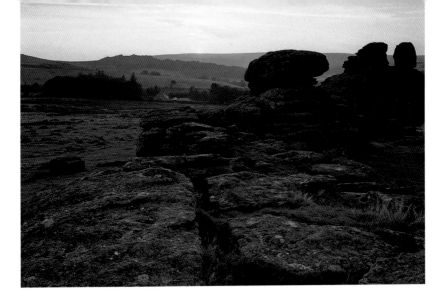

also a car park conveniently situated nearby so you don't have to walk any more than a quarter of a mile to be among the towering granite structures that have made this part of Devon famous.

The key here is foreground interest. Granite boulders in all shapes and sizes are scattered everywhere, so lock a wideangle lens onto your camera – a 28mm will be ideal – and make the most of them. For the best results, include a focal point in the distance so the eye isn't drawn through the foreground into an empty scene. Haytor, though way

Above Because Hound Tor covers a large area you can find a successful viewpoint at most times of day, from dawn to dusk. This shot was taken at sunset.
Pentax 67 with 55mm lens, 1sec at f/22, Velvia 50, 3-stop neutral-density graduated filter, tripod

Right There's never a shortage of foreground interest at Hound Tor – granite boulders, or 'clitters', are to be found everywhere. Use a wideangle lens to make the most of them.
Pentax 67 with 55mm lens, 1/4sec at f/16, Velvia 50, polarizer, 81B warm-up filters, tripod

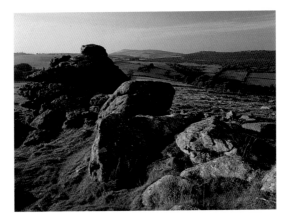

Hound Tor

So called because it is said to resemble a pack of hounds overlooking a natural battlement, Hound Tor, like the dozens of other tors in the region, was formed more than 300 million years ago when molten granite was injected into a subterranean area that would eventually become Dartmoor. Over the next 200 million years, thousands of feet of rock above was eroded until the now-solid granite was exposed. Once exposed, the granite then expanded and cracked, and during the various ice ages that occurred as recently as 10,000 years ago, repeated freezing and thawing caused the granite to break up. The tors themselves were formed by the more resilient granite that survived.

Expert Advice

My advice when you visit is to spend the first hour or so just wandering around and getting a feel for the place. One of the nice things about Hound Tor is that there's no classic view, so you know that whatever you do shoot, it's going to be different. Even when I've taken a dozen eager photographers there during landscape workshops on Dartmoor, it's surprising just how different their resulting pictures are.

off in the distance, is a dominant feature on the horizon and makes a great focal point. You also need to make sure everything is recorded in sharp focus – do that by stopping your lens down to f/11 or smaller, and focusing on the hyperfocal distance.

My favourite shot of Hound Tor to date is the main one shown here on page 46. On the day of my visit the weather was very changeable and I spent hours playing hide-and-seek with the sun. When it did make a brief appearance, though, the light was stunning.

Arriving at Hound Tor, I went for a stroll in search of a new viewpoint and found this cluster of granite 'clitters'. I was immediately drawn to the strong diagonal line they created which carried the eye through the scene towards Haytor on the distant horizon. I knew the light would break eventually, so I made sure everything was ready. After about half an hour, I got what I wanted when a hole in the clouds passed over the sun, brilliant sunlight broke through and illuminated the foreground of the scene. Taking a spot reading from the sunlit grass, I managed to expose two sheets of film before the sun was obscured by cloud and the light faded.

PLANNING

LOCATION
Hound Tor is in the heart of the Dartmoor National Park in south Devon, approximately 5 miles (8km) west of Bovey Tracey.

HOW TO GET THERE
Take the M5 to Exeter, leave at Junction 31 and take the A38 towards Newton Abbot and Torquay. Before reaching Newton Abbot, take the A382 towards Bovey Tracey. On the outskirts of town take the B3344 to Manaton and just before reaching the village take a left turn onto a minor country lane – this leads to the car park for Hound Tor.

WHERE TO STAY
Numerous farmhouse B&Bs and a few small hotels in the villages and around the moor. The Two Bridges Hotel in Two Bridges is superb, tel: +44 (o) 1822 890581, www.twobridges.co.uk
For other ideas go to www.dartmoor.co.uk

WHAT TO SHOOT
The towering granite rocks are what make Hound Tor so

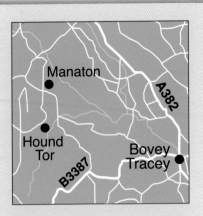

interesting. Shoot wide views plus close-ups of the patterns and textures in the rock.

WHAT TO TAKE
Lenses from wideangle to short telephoto, polarizer, warm-up and neutral-density graduated filters, plenty of film and a sturdy tripod plus cable release.

BEST TIMES OF DAY
Hound Tor covers a large area so you could spend the whole day shooting from dawn to dusk and moving to different areas to make the most of the light.

ORDNANCE SURVEY MAP
Landranger sheets 191 and 202

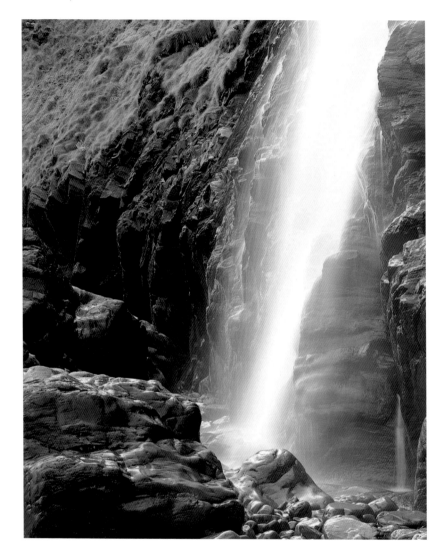

CLOSE TO THE POPULAR DEVONSHIRE VILLAGE OF CLOVELLY,
MOUTHMILL BEACH LIES ON A BLISSFULLY QUIET STRETCH OF
SHORE. PERFECT FOR ESCAPING THE CROWDS **DEREK CROUCHER**

Left This is not really the usual angle from which I might shoot a waterfall, but the slight backlighting seemed to work well, so I decided to give it a go. Detail shots can be a useful addition to wider landscapes. *Technical details not recorded*

On the north Devon coast, a few miles from the Cornish border, is the village of Clovelly, a unique little place, improbably situated on a steep hillside rising directly out of the sea. It's the type of place that is very busy with tourists in the summer, but at least its location means that all motor vehicles are banished, due to the narrow streets and gradient. I would recommend a visit, if only to watch the hotel staff using makeshift 'rafts' to drag supplies up and down the hill. If, however, you prefer to get away from the crowds and spend time on a quite stretch of coastline, then Mouthmill Beach, just around the corner, is a gem of a place.

Due to the one mile (1.6km) walk from the nearest road, this stretch of shoreline goes undiscovered by most visitors to the area, but they do miss out on an extremely fascinating place to explore. The geology is varied and colourful, and below Windbury Point at the western end, this fine waterfall crashes directly onto the rocky beach below. High on the cliffs above, the fulmars seem to just sit and watch the world go by, occasionally taking to the air to ride the clifftop updrafts.

Right This is perhaps the more traditional angle to photograph a waterfall to show the cascading effect of the water. Varying the shutter speed will give very different renditions of the water, but since I am in the habit of using slow film and small apertures, I stick to the soft, blurred effect. *Mamiya RZ67 with 110mm lens, 1/8sec at f/16, Velvia 50, tripod*

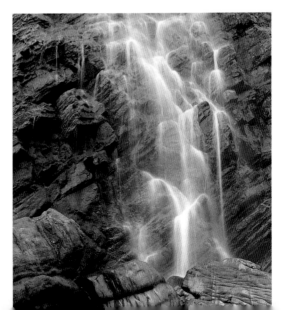

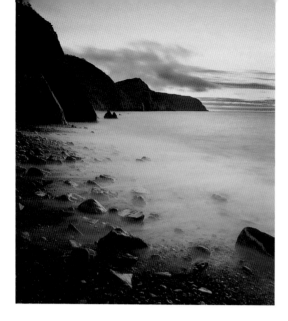

Left This type of shot can be a bit of a challenge. The strong wind meant salt spray built up on the filter in no time, plus I needed to keep repositioning as the tide retreated, and wait for a decent wave to cover the rocks. The key to getting this effect is an exposure time of at least eight seconds. *Mamiya RZ67 with 50mm lens, 16secs at f/32, Velvia 50, 3-stop and 2-stop neutral-density graduated filters, tripod*

I packed the equipment I knew I would need and set off through the woods for the beach. It's always much quicker to work when you know your exact angles, and it didn't take long to get the distant view with the 360mm lens plus a straight-on shot at the base of the fall using my 110mm. I spent a little more time mulling over this position to the side, picture on page 50. An exposure of around half a second on Velvia has given a misty effect, but I did need to wipe water spray off the lens between each frame.

picture on page 50

FACTS ABOUT:

Mouthmill Beach

This stretch of the coast, and part of the nearby woodland is owned by the National Trust. You can take the South West Coast Path, or walk from Clovelly or Brownsham Farm. Turning left at the farm and walking across the field joins the coast path before descending steeply to the shore. Alternatively, turn right for a more gentle descent through the woods by a stream. The flow of water in the fall will depend on previous rainfall, so after a dry spell you may be disappointed.

PLANNING

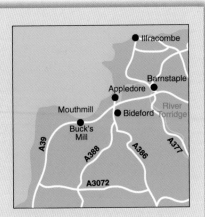

LOCATION
Mouthmill Beach is on the north Devon coast, about 9 miles (14.5km) west of Bideford.

HOW TO GET THERE
The 319 bus from Bideford to Hartland stops at Clovelly. By car, take the B3248 off the A39, then turn right through the lanes for the Brownsham car park.

WHERE TO STAY
This area has plenty of accommodation options. For full listings contact the Bideford Tourist Information Office, tel: +44 (0) 1237 477676, or go to www.visitsouthwest.co.uk

WHAT TO SHOOT
As well as the coastal subjects, the woods offer good possibilities for close-ups – there are ferns, flowers and insects along the path by the stream. Try returning to the beach around sunset and use long exposures to blur the water.

WHAT TO TAKE
I think I used most of the lenses in my kit for this shoot, and don't forget a cloth to wipe off the spray. Good walking boots.

BEST TIMES OF YEAR
Rough seas in autumn or winter could be very dramatic.

ORDNANCE SURVEY MAP
Landranger sheet 190

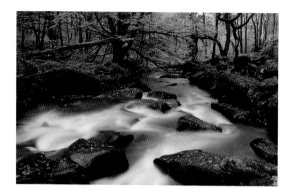

THIS AREA OF ANCIENT WOODLAND LIES ON THE SOUTHERN EDGE OF RUGGED BODMIN MOOR AND IS HOME TO A RICH HABITAT OF RARE LICHENS AND MOSSES
ROSS HODDINOTT

There are so many beautiful spots hidden in the rugged Cornish countryside that it is difficult to prefer one to any other. But Golitha Falls is one place I always return to. Golitha is found on Bodmin Moor, a short drive from the Jamaica Inn, made famous by author Daphne du Maurier and smugglers of years gone by. You can also discover the Hurlers, a Bronze Age stone circle west of nearby Minions.

Golitha has a wealth of natural history. Otters frequent the river, although count yourself lucky to see one. Woodpeckers, nuthatches and treecreepers are among the birds you can see and hear, but they rarely come close enough to photograph. In autumn many species of fungi grow here.

Do not visit expecting a vast, impressive waterfall. Instead, it's a gentle river winding through an attractive oak and beech woodland. The falls are a beautiful stretch of river where the water flows over many giant Cornish granite boulders, and it was this I intended to photograph one day in October.

Left The falls at Golitha are beautiful but well photographed. Try to choose a different angle. With this picture the impressive granite rocks covered in leaves make an interesting foreground and lead your eye through the frame. Then a slow shutter speed has blurred the water. A well-used technique, but still very effective.
Nikon F90x with 28mm lens, 2secs at f/22, Sensia 100, 81B warm-up filter, tripod

Right Just off the path I found some prominent roots which I decided were ideal for the picture I had in mind. I wanted to emphasize the colour and pattern by allowing the woodland floor to dominate the frame.
Nikon F90x with 28mm lens, exposure details not recorded, 81C warm-up filter, tripod

Left Golitha Falls is home to many species of bird, but few venture close enough to photograph well. Robins, though, are always curious and in winter a few crumbs can entice them to pose for you. *Nikon F90x with 400mm lens, 1/125sec at f/8, Sensia 100*

We had just had several days of rainfall and I knew the falls would be active. But as I walked through the woodland I found it was the freshly fallen beech leaves that caught my eye. All the warm, rich colours of autumn could be found covering the woodland floor. The roots of the trees, which had harvested the leaves, were still visible and creating beautiful natural patterns. I had chosen an overcast day for my visit, as this kind of light reproduces detail far better than harsh, contrasting light.

The reserve is managed by English Nature and has become very popular. But in autumn visitors are few. Golitha is a well-photographed location. So when I visit, I am always very conscious of trying to produce a different angle or viewpoint. The pleasure of taking a unique image, which others might also enjoy, always proves a great motivation.

FACTS ABOUT:

Golitha Falls

Golitha Falls is located where the River Fowey runs through a deep granite gorge on the southern edge of Bodmin Moor. This ancient woodland was first mentioned in the Domesday Book and is of particular importance as a rich site for lichens and mosses, which thrive in the humid conditions created by the falls. In the 19th century the woods were managed, and regularly coppiced, to supply timber for local industry. Some areas of the reserve are still traditionally coppiced today.

PLANNING

LOCATION
Southern tip of Bodmin Moor on the River Fowey. Nearest villages are St Neot and St Cleer.

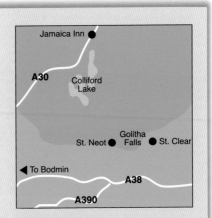

HOW TO GET THERE
Take the A30 from Launceston and turn off left at Jamaica Inn (signposted). Follow a minor road for around 6 miles (9.6km). Park in the large car park adjacent to woodland. Can also be reached from A38 west of Liskeard.

WHERE TO STAY
The famed Jamaica Inn has accommodation, tel: +44 (0) 1566 86250, www.jamaicainn.co.uk For other ideas and information go to www.visitsouthwest.co.uk

WHAT TO SHOOT
Great landscapes and close-ups of beech and oak trees in autumnal colours. Also photograph the falls using long shutter speeds. Look for fungi, lichen and moss.

WHAT TO TAKE
Always take walking boots, as it can be soft under foot in places. A tripod is essential, warm-up filters will be useful and a pocket reflector when doing macro work. Do not stray far from the paths, as the mosses are very delicate and easily damaged.

BEST TIMES OF YEAR
In the spring the fresh new growth is very attractive, and woodland flowers can also be seen and photographed.

ORDNANCE SURVEY MAP
Landranger sheet 201

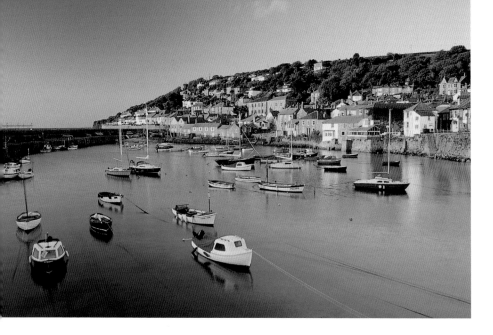

THIS UNSPOILT CORNISH FISHING VILLAGE IS A DELIGHT TO VISIT
AND MAKES A CONVENIENT BASE FOR VISITING THE POPULAR
ATTRACTIONS OF PENZANCE AND LAND'S END **ROSS HODDINOTT**

Above An early start was necessary to photograph the first rays of sun reaching the village. The warm, morning light illuminated the numerous fishermen's cottages and gave them a warm, orange glow.

Nikon F90x with 28mm lens, 1/2sec at f/22, Kodak E100VS, 3-stop neutral-density graduated filter, polarizer, tripod

A short drive from the ever-popular Penzance, Land's End and the magical, open-air Minack Theatre, Mousehole (pronounced 'Mowzel') has remained largely unspoilt and retains its classic fishing village feel. The only exception is that now ice cream and postcards sell faster than the daily fish haul, due to its popularity with tourists. Mousehole is a maze of narrow winding streets, galleries and small shops. The village itself is centred round a semicircular harbour and is protected from the might of the sea by two sturdy breakwaters. This picturesque harbour, crammed with little fishing vessels, attracts thousands of visitors annually. For this reason, summer is not the best time to visit and Christmas is also very busy. The village is well known for its impressive display of seasonal lights that extend across the harbour.

Mousehole

Mousehole

Mousehole is best known for its Christmas lights and for baking a monstrous fish pie on December 23rd every year. This date is known locally as 'Tom Bawcock's Eve' and is a day when the villagers recall the bravery of the fisherman who saved the village from famine by sailing out in a storm and returning with a large catch of fish. It's an event which has now become a major village party, attracting visitors from the surrounding district and from all over the world. Also, Dolly Pentreath, reputedly the last person speaking the Cornish language as her natural tongue, lived and died here over 200 years ago. It was believed the language died with her, but in recent times there has been a revival of interest in the Cornish language.

Photography just isn't practical when you're sharing the landscape with dozens of other people, so I prefer the quieter months of autumn and early spring. Scenic photographers know full well that the best light is during early morning and late evening. So quietly, I crept out of our cottage at 6am. The sun wasn't up yet, but it was important to get myself positioned and waiting before the first rays of light reached the village.

I already knew the view I wanted to photograph and that the sun would be behind me at sunrise. I was planning a classic view of the harbour and village and hoped the warm morning sunlight would cram my shot full of impact. Fortunately it was a still day, as the slightest breeze would have moved the fishing boats during exposure. The harbour walls cast a shadow across the fishing boats and foreground and I placed a 3-stop neutral-density filter at a slight angle over the sky and brightly lit cottages to help even out the light. With the sun rising quickly, the light was changing constantly. I had soon exposed half a roll of film, but the quality of sunlight had rapidly diminished.

Expert Advice

Mousehole harbour is a classic Cornish scene and as such has been photographed a million times. This presents a familiar headache – how do you find original angles for photography? A quick look at the postcards on sale shows many different approaches to photographing the village. The emphasis must shift towards capturing dramatic light, reflections or something similar to enable your shot to stand out as different from all the others.

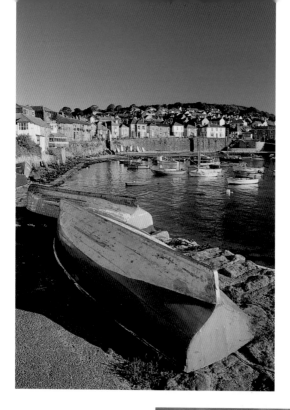

Left Photos of Mousehole are often included in local holiday brochures. While I was staying, I wanted to take a few pictures suitable for this market. This upturned rowing boat immediately drew my attention and I included it as foreground interest. I used a polarizer to saturate the blue sky.
Nikon 90x with 24–50mm lens, 1/8sec at f/22, Kodak E100VS, polarizer, tripod

Right I decided to make the most of a dull evening by using long exposures to blur the rising tide. I turned the camera vertically to emphasize the contrasting rocks and used a polarizer to lengthen the exposure and reduce glare from the stones.
Nikon 90x with 28mm lens, 4secs at f/22, Kodak EBX 100, 2-stop neutral-density graduated filter, polarizer, tripod

PLANNING

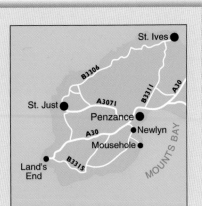

LOCATION
Mousehole is located on the south-west coast of Cornwall.

HOW TO GET THERE
Take the M5 to Exeter and then the A30 to Penzance. From there, Mousehole is clearly signposted.

WHERE TO STAY
There are numerous self-catering cottages in and around Mousehole. I booked accommodation through West Cornwall Cottage Holidays, tel: +44 (0)1736 368575, www.west cornwallcottageholidays.com Alternatively, for accommodation listings, contact the Penzance Tourist Information Centre tel: +44 (0) 1736 362207 or go to www.visitsouthwest.co.uk

WHAT TO SHOOT
The harbour, fishing boats, narrow village streets and coastal views.

WHAT TO TAKE
Make sure you have a sturdy tripod, wideangle lens, polarizing and neutural-density graduated filters. Good, supportive footwear is important if you intend to walk along the rocky shore.

BEST TIMES OF YEAR
The Christmas lights across the harbour are certainly worth photographing if you are prepared to battle against the busy crowds.

ORDNANCE SURVEY MAP
Landranger sheet 203

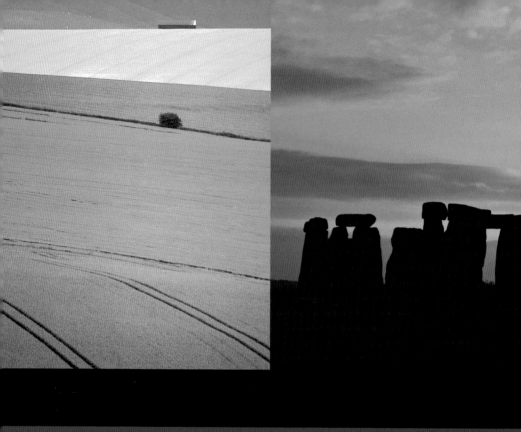

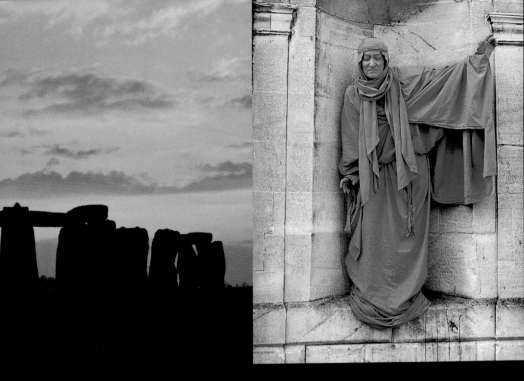

PART THREE THE WEST

Keysley Down

WILTSHIRE IS A RURAL, IDYLLIC COUNTY WITH PLENTY OF CHANCES TO PHOTOGRAPH ROLLING DOWNLAND, COLOURFUL CROPS, PRETTY MARKET TOWNS AND WHITE HORSES **COLIN VARNDELL**

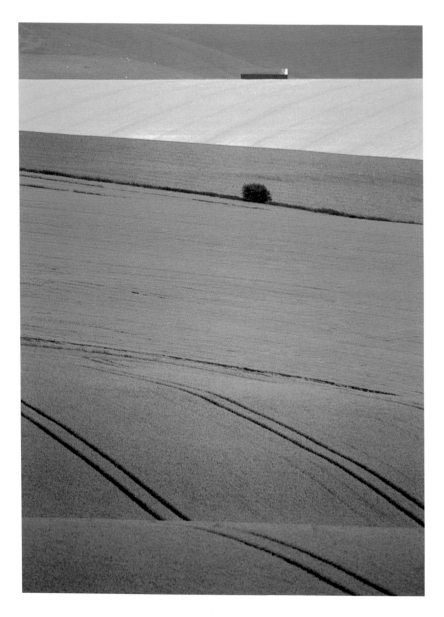

Left The message I hope this picture puts over is a simple one – here is a landscape claimed from nature, tamed by man and dominated by agriculture. Exposure was calculated by reading directly off the scene with TTL metering. *Nikon FE2 with 300mm lens and 1.4x teleconverter, exposure details not recorded*

The A303 between Wincanton and Salisbury cuts through a tract of rolling, arable downland which is rich in photo opportunities of both landscape and agricultural subjects. My own favourite area for photography in this south-east corner of Wiltshire is Keysley Down, near Mere. This landscape constantly changes with the seasons, as various crops are rotated and harvested. There are possibilities for photographs here in all seasons, but summer is arguably the best time.

I prefer to use a long telephoto lens in this huge landscape as it lends itself to selective composition, and the narrow angle of view allows the exclusion of sky in most circumstances. I always apply the rule that skies are only included if they contribute in a positive way, like adding colour or drama to an image.

I tend to return to the same favourite viewpoints because the landscape varies depending upon the state of crops. It takes 55 minutes to drive from my home to Keysley Down, over which time the weather can change dramatically. There is a solitary sweet chestnut tree standing in a field of ever-changing crops, which I have often photographed. One morning in the winter, after a light snow fall, I set off to photograph the tree, only to find that the snow petered out just west of Keysley Down.

Below right I had driven towards Wiltshire following a dark cloud which I found to be suspended over Keysley Down. It was one of those clouds that hardly moves. I waited patiently for over two hours, and about ten minutes before sunset a shaft of sharp light stabbed across to illuminate the rape field against the dark, stormy cloud backdrop. *Nikon FE2 with 300mm lens, 1/60sec at f/5.6, Kodachrome 64, tripod*

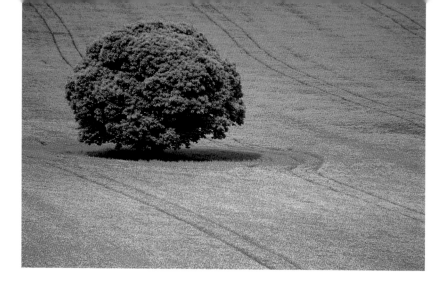

Above On the south side of the A303, a lone sweet chestnut tree stands in an arable field. It changes character with the seasons and crops. Here it stands in a linseed crop.
Nikon FE2 with 300mm lens, 1.4x converter, 1/30sec at f/11, Velvia 50, tripod

The main shot of summer crops, on page 64, was shot in portrait format as I wanted to show the many layers of crops and contours. I seek simple compositions that tell a story or portray some message. Here I felt the barn would anchor the image, while the solitary hawthorn tree is a reminder of the kind of vegetation which once naturally covered this landscape. On this occasion the sky was dull, so I excluded it to emphasize the colours and textures of the landscape. I hope this picture has a simple message – here is a landscape claimed from nature, tamed by man and dominated by agriculture.

FACTS ABOUT:

Keysley Down

The character of this landscape is the result of human activity together with the effects of natural forces over thousands of years. Following the last ice age, this land was first colonized by trees, which covered much of England. Neolithic man began clearing the forest to cultivate lowland soils. The removal of trees continued up until the last century. In recent times many ancient hedgerows, planted to make small enclosures, were grubbed up to form larger, more efficient field systems.

PLANNING

LOCATION
Keysley Down is in south-west Wiltshire, immediately north of the A303, approximately 3.5 miles (5.6km) east of Mere.

HOW TO GET THERE
From Salisbury or Andover take the A303 west towards Wincanton. About 1 mile (1.6km) after the junction with the A350, watch for Willoughby service station on the left. From here the area immediately north is Keysley Down. The main picture, see page 64, was shot from the opposite side of the road. A short distance further west is a layby which provides panoramic views.

WHERE TO STAY
The Prince Leopold Hotel in Warminster is recommended, tel: +44 (0) 1985 850460, www.princeleopoldinn.co.uk For other ideas go to www.visitwiltshire.co.uk

WHAT TO SHOOT
Agricultural landscapes and farming activities, silhouetted trees against morning or evening skies in winter.

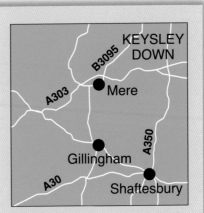

WHAT TO TAKE
Telephoto lenses are useful for selecting features from this huge landscape. Wear bright clothing, as you will never be far from a road.

BEST TIMES OF YEAR
Spring and summer are best for colourful crops. In summer I prefer evening light because its quality can often be assessed before making the trip. During autumn there is heightened agricultural activity as crops are harvested and the fields ploughed. In winter go for bare tree silhouettes.

ORDNANCE SURVEY MAP
Landranger sheet 183

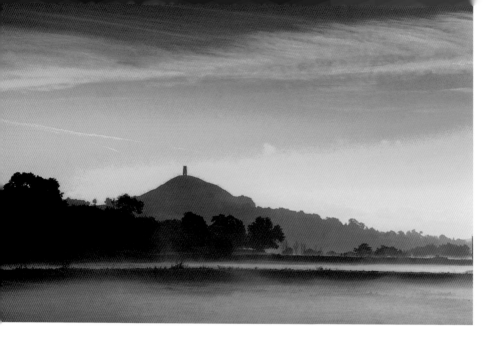

GLASTONBURY IS A TOWN SURROUNDED WITH MYTH, LEGEND AND SACRED SITES. VISITORS FLOCK FOR THE FAMOUS MUSIC FESTIVAL AND TO DISCOVER ITS MYSTICAL SECRETS **GUY EDWARDES**

The legendary Isle of Avalon was once a true island, but now sits isolated in the vast expanse of low-lying marshy meadows that form the Somerset Levels. This is the location of the town of Glastonbury, which is dominated by the world-famous landmark of Glastonbury Tor – a mound of volcanic rock that juts from the surrounding countryside. Its grassy terraced slopes are crowned by a single 15th century tower – the remains of one of many churches that once stood upon the site. This location requires exceptional conditions in order to convey its character. The atmosphere of a misty autumn morning can help to capture its spirit.

The main image here was taken on just such a morning in mid-October. A period of showery weather had been followed by a warm sunny day with clear skies. I knew that if the night stayed clear the air

Above This image was taken from the side of the A39 on the banks of the River Brue, on the outskirts of Glastonbury. Although I don't usually like a lot of sky in my landscape photographs, I felt that on this occasion the band of high cirrus cloud helped to balance the composition.
Canon EOS 5 with 28–105mm lens, 1/15sec at f/11, Velvia 50, 2-stop neutral-density graduated filter, tripod

Glastonbury Tor

Glastonbury Tor

Glastonbury is a small Somerset market town with a population of about 8,000. It is steeped in history and has a wealth of myths and legends associated with it. The tor itself sits atop the Isle of Avalon – reputed to be the place where King Arthur's sword Excalibur was forged and the site where Arthur came to heal his wounds. Glastonbury is also the site of the first Christian church in Britain and the place where Joseph of Arimathea is said to have landed with the Holy Grail. It was once believed that the tor was hollow – the entrance to the underworld, and a place where fairy folk live. The tor is now owned by the National Trust and is always open to the public.

temperature would drop, resulting in the formation of mist over the damp moors around Glastonbury. When I looked out of my window at 5am, the sky was full of stars. I had just enough time to drive to Glastonbury to catch the sunrise. Upon reaching the edge of the Blackdown Hills I was relieved to see that my early start had not been in vain. The whole of the Somerset Levels was shrouded in a veil of white mist, broken only by the tallest trees, church towers and inevitable pylons. A little further on I caught a hazy glimpse of the tor through the mist. I noticed that from this particular angle I could see directly through the doorways of St Michael's Tower which sits on top of the tor. From past experience I knew this would help to distinguish it as a building rather than a cairn or obelisk – especially when photographing it from a distance or as a silhouette.

I feel the tor needs to be viewed within its surroundings to fully appreciate its status. Luckily, conditions on this particular morning were perfect to convey a feeling of the mystical atmosphere required for an image of such an ancient spiritual site.

Expert Advice

Other places of interest in the area include Glastonbury Abbey, Glastonbury town, the Somerset Levels, West Sedgemoor RSPB reserve, Cheddar Gorge and Ebber Gorge.

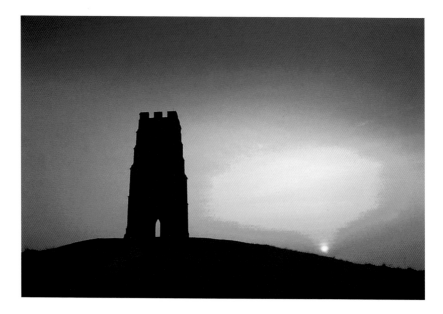

Above This image of St Michael's Tower was taken just after sunrise from the top of the tor. It is best to arrive early if you don't want hordes of people in your shot, as the tor gets hundreds of visitors throughout the year – many of whom stay around until sunset. If you do want to photograph people there will be plenty of characters here, especially around the time of the Glastonbury Music Festival.
Canon EOS 5 with 28–105mm lens, 1/45sec at f/8, Velvia 50, 2-stop neutral-density graduated filter, tripod

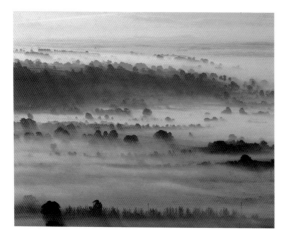

Left The view from the top of Glastonbury Tor can be breathtaking. On this occasion it was almost impossible to tell where the land stopped and the sky began. Catch the trees and hedges emerging as the mist gradually burns away. *Canon EOS 5 with 70–200mm lens, 1/15sec at f/16, Velvia 50, tripod*

PLANNING

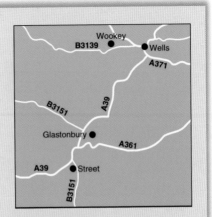

LOCATION
Glastonbury Tor is situated next to Glastonbury in Somerset.

HOW TO GET THERE
From the north and west come off the M5 at Junction 23 to join the A39 towards Glastonbury. From the east, take either the A361 into the town, or the faster A303 coming off at Podimore to join the A372 then the B3151. A minor road loops around the tor, with parking.

WHERE TO STAY
Find full listings at the Glastonbury Tourist Information Centre, tel: +44 (0) 1458 832954 or go to www.glastonbury.co.uk

WHAT TO SHOOT
I like to shoot the tor from a distance, including some of the surrounding landscape. The section of the A39 between Street and Glastonbury provides good views, as does Walton Hill – just south-west of Street. The hillsides below St Michael's Tower are terraced and can look good when lit obliquely by the sun. From the top of the tor there are spectacular views of the countryside.

WHAT TO TAKE
I use lenses from 24mm – 400mm. A polarizing filter may be useful, while neutral-density filters are often essential. The countryside becomes waterlogged during autumn and winter months so wellington boots are advisable.

BEST TIMES OF YEAR
Any time of year, but as usual early and late in the day are best. Misty conditions can occur in any month as long as the ground stays damp. The area can become very crowded around the time of the Glastonbury Music Festival, which is held most years, towards the end of June.

ORDNANCE SURVEY MAP
Landranger sheets 182 and 183

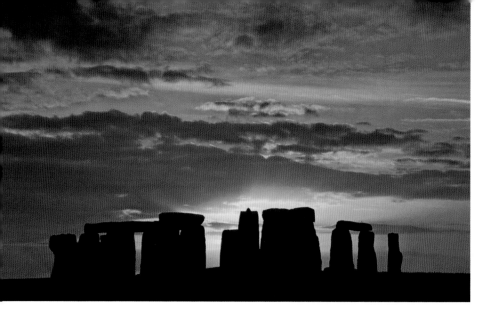

THIS STANDING STONE CIRCLE IN THE HEART OF WILTSHIRE IS AN
ICONIC IMAGE OF THE ENGLISH LANDSCAPE – RECOGNIZED
WORLDWIDE FOR ITS MYSTERIOUS NATURE **GUY EDWARDES**

Stonehenge is perhaps the best-known ancient monument in Britain and has long been a Mecca for tourists from around the world. Consequently there must have been millions of photographs taken here over the last 100 years. Finding a new angle from which to work has become more and more difficult since security on the site was increased in the 1970s to prevent vandalism of the stones.

There are some good angles to be found within the enclosed area owned by English Nature, but I have always found it better to view the stones from further away as an element within the wider landscape. Be aware that there are many modern features in the surrounding landscape, such as fences and road signs that you will need to compose around if you want to maintain the mood of the location. During the summer the height of vegetation in the surrounding fields can help to conceal many of these.

Above A view of the monoliths taken from the roadside. This image was taken at sunset in June. I used a small stepladder to be able to shoot over the perimeter fence and add some height. *Canon EOS 3 with 70–200mm lens, Velvia 50, 1/30sec at f/11*

Stonehenge

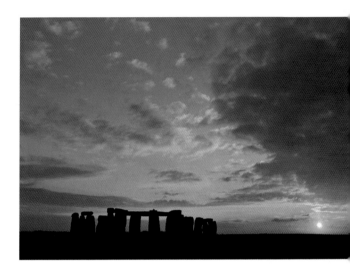

Right This image was also taken at sunset in June from the roadside. Using a small stepladder helped to gain a little extra height and provide a clear view over the perimeter fence.
Canon EOS 1Ds with 28–70mm lens, ISO 100, 1/30sec at f/11

The biggest headache for photographers will be the number of people walking the path around the stones during the day. There isn't really a best time of the year to avoid the tourists as the site is so popular, therefore patience will be the key. However, it is advisable to avoid midsummer's days unless you want to photograph crowd scenes.

The main image here was taken in June, when it is possible to shoot the stones from the roadside as a silhouette against the setting sun. I took a tall tripod and a small stepladder to gain a clear vantage point over the chain-link fence. I took a spot meter reading from the brightest section of sky and increased the suggested exposure by one stop so that it would record on film as a light tone. The stones were a full five stops darker, so I knew they would record as solid black. As I had my tripod at full extension with the centre column raised, I set mirror lock-up and two-second self-timer on my camera to avoid any potential vibration spoiling the image.

There are numerous vantage points from which to photograph the stones, so don't restrict yourself to the roadside. Footpaths lead across the downs from

Expert Advice
The two hours around both sunrise and sunset offer the best lighting conditions for photography – especially for timeless images that capture the character of the place. Dawn visits may benefit from low-lying mist, which can help to conceal fences, and patrolling security guards and can also add atmosphere and drama to your images.

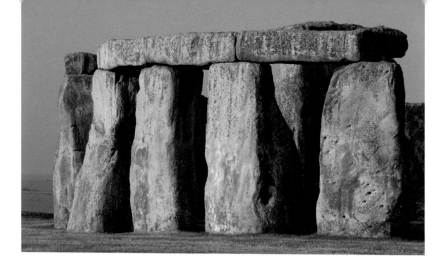

Above For this image I chose to use a telephoto lens to crop in closely on the sunlit monoliths. *Canon EOS 3 with 100–400mm lens, 1/8sec at f/16, Velvia 50, polarizer*

the car park. To the north of the monument is an area known as The Cursus, which provides a clear view of the monoliths. This is a good location from which to photograph the stones set within the surrounding landscape. A green lane to the west of Stonehenge provides a similar view albeit from a slightly elevated position. Both locations can provide particularly good results at sunrise.

Stonehenge

FACTS ABOUT:

Stonehenge is one of the most important and famous prehistoric sites in the UK. It is said to have been built around 3100BC. It is still not fully understood why the stone circle was constructed. Some think it was used for human sacrifice, others believe it to have been used for astronomy. Many of the smaller stones were transported all the way from south-west Wales, while the larger monoliths were sourced locally. Stonehenge is now owned and managed by English Heritage. Access is restricted and you are unable to walk freely among the stones without permission. Photography from within the site for publication requires a permit but amateur photography is welcomed.

PLANNING

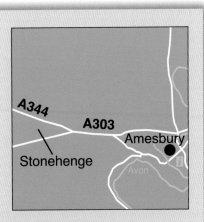

LOCATION
Stonehenge, Wiltshire

HOW TO GET THERE
Stonehenge is located 2 miles (3.2km) west of Amesbury on the junction of the A303 and A344/360. Nearest train station is in Salisbury. Bus services go as far as Amesbury.

WHERE TO STAY
Plenty of accommodation is available in nearby Salisbury. For full listings contact the Salisbury Tourist Information Centre, tel: +44 (0) 1722 334956, or go to www.visitsalisbury.com

WHAT TO SHOOT
Sunrise offers the best opportunities, especially on a misty morning. It is possible to get good images at sunset. Unfortunately, the site is closed when the light is at its best, but decent photographs can be taken from around the security fence and from surrounding footpaths. For visitor information, opening times and entrance fees go to www.stonehenge.co.uk

WHAT TO TAKE
Lenses in the range of 28mm – 400mm can all be employed. A polarizing filter may help to enhance an interesting sky; while neutral-density graduated filters may come in handy at times.

BEST TIMES OF YEAR
Stonehenge is located in the open rolling downs of Salisbury Plain. The surrounding landscape offers many opportunities for landscape photography throughout the year – especially during the summer months and around harvest time. There are also several nature reserves nearby that are excellent for photographing wild flowers and insects.

ORDNANCE SURVEY MAP
Landranger sheet 184

THIS VIBRANT, CULTURAL, WORLD HERITAGE CITY IS A DELIGHT FOR ARCHITECTURE LOVERS. DISCOVER THE 15TH-CENTURY ABBEY, ROMAN BATHS AND GRAND GEORGIAN HOUSES **STEVE DAY**

Most of the important buildings in Bath were built in the Georgian period and were designed by John Wood the Elder and his son, the Younger – the same stone was used for the minor housing. Terrace upon terrace of this mellow, warm-toned stone captures the glow of the light. The repetition of colour and structure photographically produces pleasing pictures, be they broad views or isolated elements of recurring patterns.

The whole city has many terraces, crescents and roads with unspoilt Georgian architecture, the most famous being the Royal Crescent. To photograph the entire sweep of the crescent requires either a panoramic camera or a helicopter, neither of which I have. But by homing in on the repeated pattern of the columns a sense of harmony can be conveyed.

Below The Circus is a good place for pattern pictures.
Canon EOS 50E with 28–105mm lens, 1/15sec at f/22, Velvia 50, mirror lock-up, cable release, tripod

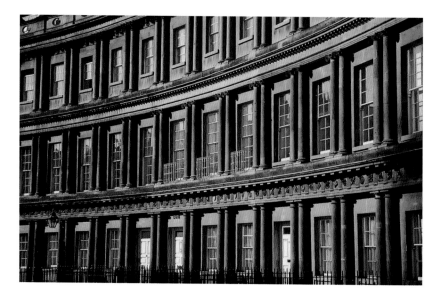

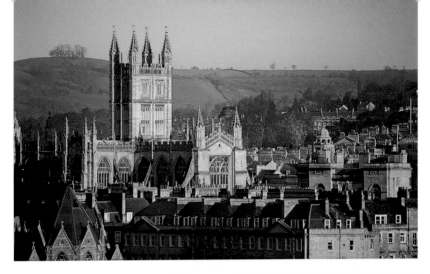

Above An early-morning shot of the abbey viewed from the far side of the Avon, as you climb up to Alexandra park.
Canon EOS 50E with 100–300mm lens, 1/8sec at f/11, Velvia 50, polarizer, mirror lock-up, cable release, tripod

Right Many of the street performers are 'living statues', and he's one of the best, not only because he stands so still but because the blue costume contrasts splendidly with the stonework.
Canon EOS 50E with 28–105mm lens, 1/125sec at f/8, Velvia 50, mirror lock-up, cable release, tripod

Expert Advice

The correct exposure to use when shooting buildings of Bath stone is at least one stop over the camera's meter reading. The stone is lighter than midtone, and an internal meter will underexpose. Use an incident lightmeter (as I did) or take a reading from a nearby subject that is midtoned.

Bath isn't just about Georgian architecture, though. The 15th-century Bath Abbey is beautiful, both inside and out, though the exterior is hard to shoot because it's hemmed in by surrounding buildings. The best views are from the Parade Gardens, or from the south bank of the Avon. Also, go to Alexandra Park, where you will find panoramic views of the whole city.

The Roman Baths are interesting to look at but, like the Abbey, are hard to photograph, being surrounded by tall walls and so in deep shade except for the middle of the day.

Don't miss Pulteney Bridge. The shops on the bridge make good subjects, and the view up the river towards the bridge is a classic, especially at night when it's lit. Also, keep an eye out for some of the minor streets – they are equally attractive.

As you wander the city – which you must as there are three or four days of good photography to be found, and even then that would be almost superficial – you'll find that street theatre is omnipresent, entertaining and photogenic – if you photograph them remember to make a donation.

FACTS ABOUT: Bath

The city's unique claim to fame is that it has the only hot springs in Britain – a fact that led to the Romans starting the development of the city around 40AD. The 15th century saw the building of the third abbey, and the wool trade further enhanced the city's status. The pace of development speeded up upon the arrival of Queen Anne in the early 1700s, followed by the gambler Richard 'Beau' Nash, who quickly started to impose order on the city. Ralph Allen also then arrived, did well and bought the nearby stone quarries. A combination of Nash, Allen and the architects John Wood and his son created the harmonious Georgian city of today.

PLANNING

LOCATION
Bath is in the Avon Valley in Somerset.

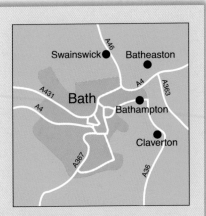

HOW TO GET THERE
Bath is on the Paddington-to-Bristol train line, and the main roads into it are the A46, the A4 or the A36. For getting around, its best to take to your feet and walk – parking is awful and the city is actually very compact.

WHERE TO STAY
There is a good range of hotels and B&Bs, at all prices. Contact the Bath Tourist Information Centre, tel: +44 (0) 906 7112000, or go to www.visitbath.co.uk
There are bars, cafés and restaurants catering for all tastes and prices, and vegetarians will be delighted with the larger than usual choice.

WHAT TO SHOOT
There are plenty of good subjects – the Royal Crescent from Royal Victoria Park is great, the Theatre Royal is a gem and Sally Lunn's House (a café) is pretty. The architecture is definitely the main attraction, but the street life is good too.

WHAT TO TAKE
A mid-range zoom lens is useful for precision framing and a polarizer to saturate colours and eliminate unwanted reflections.

BEST TIMES OF YEAR
The town is interesting throughout the whole year. Winter's low light is excellent, but gives limited time. The best time is in autumn or spring – when there is good light and more time.

ORDNANCE SURVEY MAP
Landranger sheet 172

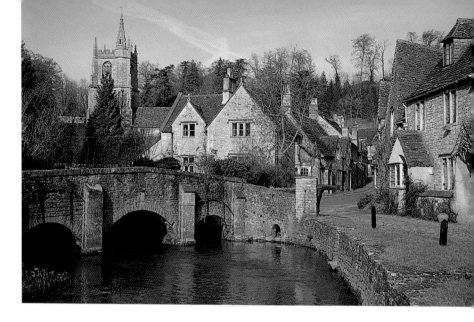

THIS CHOCOLATE-BOX VILLAGE OF COTSWOLD-STONE COTTAGES
AND TRADITIONAL CHARM IS A POPULAR TOURIST ATTRACTION,
BUT IT IS POSSIBLE TO ESCAPE THE CROWDS **STEVE DAY**

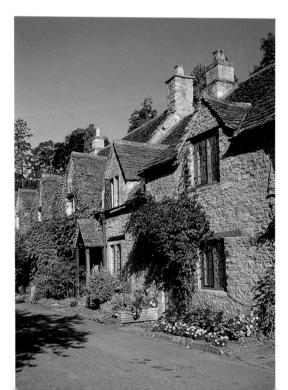

Left Wander the village. The Cotswold stone and tiled roofs make a lovely subject, especially in early summer when the flowers are flowering. *Canon EOS 50E with 20–35mm lens, exposure details not recorded, Velvia 50, tripod*

Left Though I usually like strong, sharp light, sometimes a softer, more muted illumination works well. The thin veil of cloud has softened harsh shadows and bathes the scene in warmth that brings out the mellow colour of the stone. Here I was standing in the By Brook (it's very shallow) to get this picture. A warm-up filter was used to enhance the colours. *Canon EOS 50E with 20–35mm lens, 1/8sec at f/22, Velvia 50, 81A warm-up filters, polarizer*

Castle Combe used to be a peaceful and tranquil village, unknown to most. A combination of a 1962 competition by a US travel company, which voted it 'the prettiest village in Britain', and it being the location for the filming of *Dr Dolittle* resulted in it suddenly becoming one of the most visited villages in the country.

Don't let that put you off, though – get your timing right and you can have the place largely to yourself. Early morning is best, though unlike the usual advice don't go too early – the village lies in a deep valley and it takes time for the sun to come over the hills. This is annoying because it means missing the morning 'golden hour'.

The most famous view, is down at the far end of the village, just beyond the old stone bridge, looking back up the main street. It's not surprising – with the gentle By Brook in the foreground, the row of old cottages to the right, the beautiful old bridge and the church tower beyond, it's a fine subject.

There are some real problems in making the best of it though. Due to the steep valley and surrounding trees, the sun doesn't come into the right position until around midday, and after 2pm the bridge is in deep shadow. Quite the worst time to be attempting to take landscape pictures.

FACTS ABOUT:

Castle Combe

Though a Wiltshire village, it's really part of the Cotswolds, and the vast majority of the buildings are built of the local stone. In Roman times there was a villa here, and later a Norman castle, neither of which remain. It was a bustling town in medieval times, being the centre of a thriving weaving industry, with many watermills. A red and white cloth was made here, called Castlecombe Cloth. St Andrew's church is an indicator of the village's former status, being rather grand.

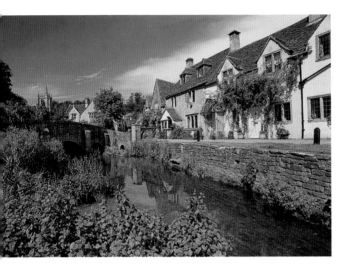

Left This is pretty much the standard shot taken by most people. The problem is that it's hard to get interesting light because this part of the village only gets the sun in mid-afternoon, and quickly loses it behind trees and hills. Also, there's only a short period when both the cottages on the right and the bridge are both lit. *Canon EOS 50E with 20–35mm lens, 1/15sec at f/16, Velvia 50, polarizer*

Much to my surprise, I achieved my best results on a hazy-cloud day. I normally don't like such light – it's too wishy-washy – but it really suited the subject. Maybe it's because the mellow stone appeared to glow in such a light, and maybe it's because the haziness reduced the harshness of the light and softened the shadows – all I know is that it worked. Do be careful if you go there on a bright day – in strong sunlight the pale Cotswold stone gives a reading between half and one stop out, so you need to overexpose by that amount.

Having done the 'stock' shot, potter around the village. The church is lovely, as is the adjacent market cross and there are a few back streets in the village and some fine old houses. Don't just settle for the village – to the south lies Becker's Wood – go there in late May and you're transported to Italy – tens of thousands of ramsons, all wafting garlic into the air.

Wander the paths that crisscross the By Brook – rural England at its best – then take a look at Rack Hill, where there are the finest, and largest, field maples I've ever seen. Finally, you must visit a small copse, simply for its name – Bottom of Jeremies.

PLANNING

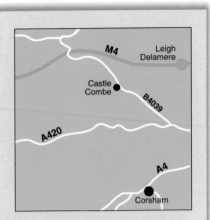

LOCATION

About 6 miles (9.6km) north-west of Chippenham, Wiltshire.

HOW TO GET THERE

Take the A420 west from Chippenham. After about 4 miles (6.4km) take the B4039 road north-west (clearly signposted Castle Combe), pass through Yatton Keynell and then follow the signs. Note – do not try to park in the village – it's usually impossible, and undesirable anyway. There is a large car park on the outskirts of the village.

WHERE TO STAY

For listings of accommodation go to www.castle-combe.com or www.cotswolds.com
Alternatively, contact the Chippenham Tourist Information Centre, tel: +44 (0) 1249 665970.

WHAT TO SHOOT

Don't just take the obvious shot of the bridge with the church behind. Explore the village – there are many beautiful buildings – and venture out onto the nearby footpaths and explore.

BEST TIMES OF YEAR

Avoid weekends, and school and Bank Holidays as they can be extremely busy. Tranquillity only exists early in the morning or late in the evening. The village seems to cope with its fame well, and the tourists come in waves as they are decanted from coaches. Time your visit well and you'll see the village at its best.

ORDNANCE SURVEY MAP

Landranger sheet 173

Westonbirt Arboretum

FAMOUS FOR ITS MAGNIFICENT AUTUMN COLOUR, WESTONBIRT ARBORETUM IS A FAVOURITE LOCATION FOR PHOTOGRAPHERS AND NATURE-LOVERS ALIKE **DAVID CANTRILLE**

Left The sky on this day was overcast, which was absolutely ideal for what I wanted – as direct sun would detract from the vibrant colours.
Canon EOS1N with 17–35mm lens, 5secs at f/22, warm-up filters, polarizer

Autumn is a wonderful time to visit Westonbirt Arboretum. Although no small journey from where I live (two hours on fairly empty roads), the draw is the reds and golds of autumn leaves, principally of the *Acer palmatum* (Japanese maple) whose palmate leaves turn brilliant orange, red or yellow.

Particularly fine autumn colour is apparently caused by favourable weather conditions: a very warm late summer coupled with a wet September means the trees are still growing and storing nutrients right into autumn. This causes the leaves to be packed full of sugars and starches, thus creating the dramatic and vibrant colours.

Right By now, there was slightly more wind so I utilized this to create movement in my shot. By extending the exposure time and allowing the branches to wave about, I managed to create a blurred impression in the foliage. This, I felt, made a different picture. Looking through the viewfinder, I thought the overall effect was of a 3D image. The yellow/blue filter, turned slightly towards the yellow section, enhanced the colour.
Canon EOS1N with 17–35mm lens, 8secs at f/22, polarizer, tripod

Westonbirt Arboretum

Founded in 1829 by Robert Holford, a wealthy landowner, who planted trees for his own interest and pleasure, Westonbirt has grown into an arboretum with 18,000 specimens and 17 miles (27.4km) of way-marked paths. It has one of the finest collections of trees and shrubs in the world. Since 1956 Westonbirt has been managed by the Forestry Commission. Facilities include a visitor centre, cafe, toilets and a plant centre. There is also a limited supply of wheelchairs available (ring to reserve, see planning box opposite for details).

I rang the Arboretum, see planning box for contact detials, to check the peak time for the colour display, which was around October 28th on that particular year. I was after shots with colour saturation, to show these glorious trees to their best advantage. I also wanted to isolate individual trees, partly to show their solo display but also to prevent human intrusion into the picture – a lot of other people had come to see the autumn colours, though the place is so large it is not difficult to lose most of them.

Expert Advice

Westonbirt Arboretum is very happy for amateur photographers to wander round with tripods taking any pictures they like; however, the Arboretum would need to know if anyone is taking pictures for commercial use as licences and/or facility fees are involved.

One way to get a feeling of the shape and colour of a tree is to look up from underneath. (I discovered in New England how most people's viewpoint seems to remain below eye level; many people asked what I was taking pictures of when they saw my camera pointed skyward to the canopy of trees.) There was also a carpet of fallen leaves around many of the maples that I wanted to incorporate into the pictures, and I experimented with long exposures to allow the moving branches to blur the leaves.

The main photograph of an *Acer palmatum*, on page 84, shows the tree shape and the fallen leaves as a feature. Leaves were red and gold – the polarizer and warm-up filters emphasized the colours and I focused in close to exclude other human presence.

PLANNING

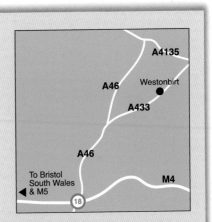

LOCATION
Westonbirt Arboretum can be found on the A433 near Tetbury in Gloucestershire.

HOW TO GET THERE
From the M4 take the A46 turnoff at Junction 18; from the north take the A433 out of Cirencester. Nearby towns of interest include Tetbury and Malmesbury. The nearest railway station is at Kemble, 7 miles (11.2km) from Westonbirt, on the line from Paddington; from Kemble there is a local bus service to Westonbirt. For opening times, tel: +44 (0) 1666 880220 or go to www.forestry.gov.uk/westonbirt

WHERE TO STAY
The Hare and Hounds, a mile down the road, has accommodation, tel: +44 (0) 1666 881000, www.hareandhoundshotel.com For other ideas go to www.cotswolds.com

WHAT TO SHOOT
Magnificent trees, leaf studies, autumn colour.

WHAT TO TAKE
Tripod, wideangle, zoom and macro lenses. Wellington boots are advisable as there is much long grass, particularly in Silk Wood. Some paths are gravelled but if venturing away from these, waterproof footwear is essential.

BEST TIMES OF YEAR
Apart from the time of leaf fall in October/November, other seasons worth visiting are spring for azaleas, rhododendrons, magnolias and camellias, early summer for the magnificent carpet of bluebells in Silk Wood and winter for frost and snow.

ORDNANCE SURVEY MAP
Landranger sheet 173

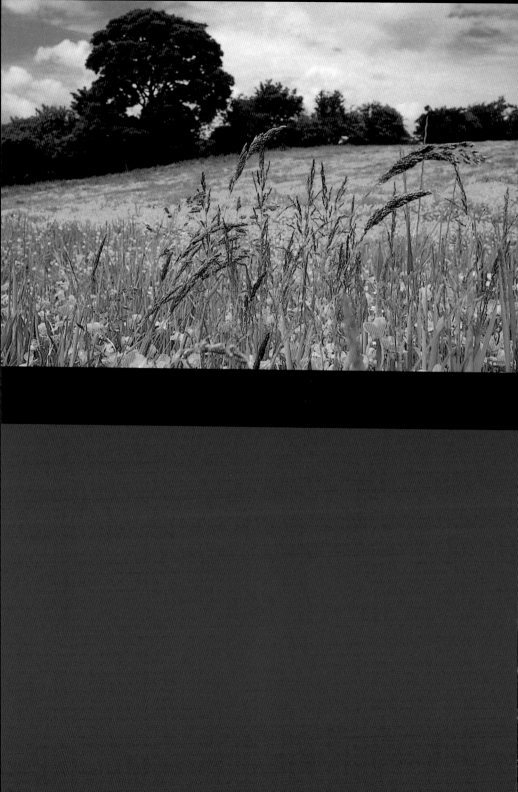

PART FOUR CENTRAL ENGLAND

THE ANCIENT MALVERN HILLS IN WORCESTERSHIRE OFFER SOME STUNNING VIEWS, SWEEPING AS FAR AS THE COTSWOLDS, SHROPSHIRE AND WALES **STEVE GOSLING**

The jagged outline of the Malvern Hills rises from the flat plain of the River Severn in Worcestershire and their contrast with the surrounding countryside makes them instantly recognizable for some distance away. The hills offer excellent ridge walking, with beautiful views east and west over rural England and into Wales. I lived in Worcester for ten years and grew to love these hills and, although I moved from the area several years ago, I return regularly with my family to walk and take photographs. I have therefore

Below Worcestershire Beacon, the highest point in the Malvern Hills, rises above an early morning autumn mist.
Canon EOS 1N with 35–135mm lens, 1/5sec at f/22, Elite Chrome 100, 81B and neutral-density graduated filters, tripod

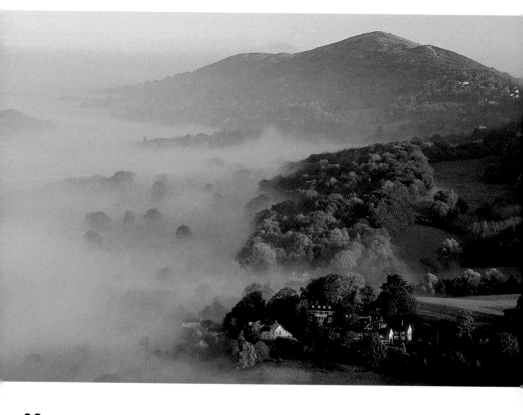

Left I arrived on the hills at 7am and the mist was so thick I could only see for 20 yards. I waited and my perseverance paid off – two hours later the mist began to clear. *Canon EOS1N with 20–35mm lens, 1/16sec at f/22, Ektachrome 100, 81B and neutral-density graduated filters, tripod*

seen them at all times of day and year but consider early morning in the autumn to be my favourite for atmospheric photography. The variety of weather conditions that prevail at this time of year can result in dramatically different photographs

It was on a cold and misty autumn morning that I rose at about 5.30am and looked out of the window to be greeted by a thick grey mist concealing all but the closest details. I knew that these weather conditions would be ideal. Frequently, when the valley is cloaked in mist the tops of the hills are clear.

FACTS ABOUT:

The Malvern Hills

The rocks of the Malvern Hills are so old they were formed before life existed on earth. Some of the rocks date from before 200 million years ago. For over 100 years they have been looked after by the Malvern Hills Conservators. This independent body attempts to balance the protection and preservation of the hills against their value as a site for a variety of leisure pursuits, which today includes walking, horse riding, mountain biking and hang-gliding.

Above Another early morning found me on the eerily named Hangman's Hill, south of Herefordshire Beacon. Framing the tree to give some foreground interest and depth to the shot,
I waited for the sun to break through the clouds to illuminate the plain below.
Canon EOS1N with 20–35mm lens, 1/20sec at f/22, 81C warm-up filter, Ektachrome 100, tripod

I had chosen my viewpoint carefully: I wanted to capture the highest point of the Malvern Hills, the Worcestershire Beacon, which stands at 1,394 ft (425m), rising out of the mist. I therefore had to seek high ground. To get a clear view and to be able to look down on the mist in the valley below, I chose to shoot looking north from the Herefordshire Beacon, also known as 'British Camp Hill' – height 1,109ft (338m). This viewpoint has the added advantage of being a short climb from the car park.

The scene before me was magical and justified the early rise. The sun was shining brightly on those parts of the landscape emerging from the mist, which was rolling backwards and forwards across the valley, like the tropical sea that would have surrounded the ridge of these hills 500 million years ago. The landscape below me was constantly changing as the mist revealed and concealed at one and the same time. Occasionally the mist would lap at my feet – I knew I would have to work quickly if I was to capture the view on film. I framed the shot to accentuate the mist in the foreground and to emphasize the isolated Worcestershire Beacon rising out of it in the distance.

PLANNING

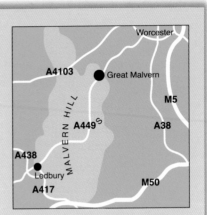

LOCATION

Great Malvern (the largest of the communities around the hills) is situated on the A449 and is about 12 miles (19.3km) from Worcester and 8 miles (12.9km) from Ledbury.

HOW TO GET THERE

Public transport access is good – the area is served well by local buses and there are rail stations at Great Malvern, Malvern Link and Colwall. Access by car is easy. The M5 and the M50 are not far away.

WHERE TO STAY

There are numerous hotels, B&Bs and pubs offering accommodation in the area – contact the Malvern Tourist Information Office for more details, tel: +44 (0) 1684 892289 or go to www.heartofengland.com

WHAT TO SHOOT

The area offers a great variety of landscape opportunities. The Malvern Priory church in Great Malvern or Little Malvern Priory for those interested in architectural photography. Further afield are the cathedral cities of Worcester, Gloucester and Hereford or picturesque villages such as Elmley Castle, Weobley, Pembridge and Eardisland, as well as many historic houses and gardens.

WHAT TO TAKE

A wide range of lenses, walking boots and additional clothing (windproof and waterproof). Early morning or late in the day, can be chilly on the top of the hills, even in summer. Always take a sturdy but preferably lightweight tripod and a torch if you plan to walk before sunrise or after sunset.

BEST TIMES OF YEAR

Spring offers similar lighting conditions to autumn. The hills can be easily approached during winter for dramatic scenery, especially after a dusting of snow.

ORDNANCE SURVEY MAP

Landranger sheet 150

THE LUSH HILLS AND VALLEYS OF SOUTH SHROPSHIRE ARE SOMETIMES LIKENED TO THE SWISS ALPS, PROVIDING A HAVEN FOR RAMBLERS AND NATURE-LOVERS **PAUL MIGUEL**

Above A low viewpoint emphasized the waving barley, with the two majestic oak trees in the distance providing a sense of scale. Now all it needed was a long shutter speed, with the exposure made during a gust of wind.
Canon AE1 with 28mm lens, 1/4sec at f/22, Velvia 50, 81B warm-up filter, polarizer, cable release, tripod

As seasons go, I have to admit that summer is not my favourite time of the year. The sun can be too harsh, the temperatures too sticky, and it's during the summer months that my hay fever makes an unwelcome return. However, I still can't fail to enjoy walking through the country lanes on those warm summer days, with a gentle breeze in the air,

It's on days like these that my thoughts turn to photography, and in my mind I envisage scenes of swirling buttercups, fluffy white clouds and deep blue skies; and they are there for the taking if you're willing to put in the time to find them. In the hope of getting some decent summer pictures, I returned to an old haunt in Shropshire, where I used to visit in the long summer holidays as a child.

The historic market town of Church Stretton lies in the south of the county. This relatively undiscovered village is situated within a valley and has been dubbed

'Little Switzerland' on account of the surrounding and sometimes snow-capped hills. A haven for walkers and ramblers, the area boasts a 12-mile (19.3km) stretch of hills known as the Long Mynd. However, for this visit I was after the lower ground, and hopefully an image that would sum up the essence of the quintessential British summer – the rape fields and buttercups, shimmering in the heat and the crop fields swaying in the breeze.

As I walked along my chosen route through farmland, my attention was suddenly drawn to one of the many crop fields off the quiet country lane. This was a beautiful barley field, but with two old oak trees situated perfectly in the centre. I immediately started to assess the situation. I began by trying out various viewpoints; stopping at a number of different points until I was eventually happy with my composition.

I was pleased to see that the furrows in the field worked beautifully, helping to lead the eye into the picture, with the two sturdy old oaks providing

Below Rabbits often frequent buttercup fields in the summer. After some searching and preparation, I photographed this individual from a nearby ditch.
Canon EOS 5 with 300mm lens and 1.4x teleconverter, 1/60sec at f/5.6, Velvia 50 rated at ISO 100, beanbag

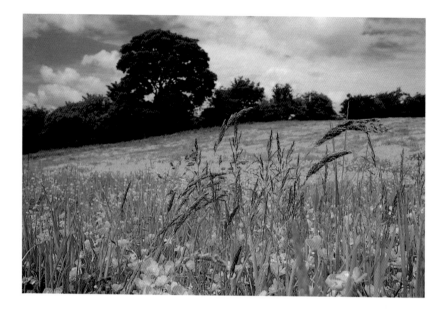

Above I shot this buttercup meadow from a low angle, opting to concentrate on the attractive foreground grasses. *Canon AE1 with 28mm lens, 1/250sec at f/4, Velvia 50*

points of interest deeper within the frame. The sky couldn't have been better, with a good dose of fluffy white cloud. Usually when photographing, I wait for a lull in any breeze to be sure of obtaining a sharp picture. However, on this occasion the breeze was a blessing. Using a slow shutter speed, I was able to add an impressionistic touch, as that grand sea of barley rippled gently, providing me with an image that did justice to the day, and also to the season.

FACTS ABOUT: Church Stretton

Church Stretton is at the heart of the South Shropshire Hills. This area has been designated as a Site of Special Scientific Interest, as it is an extremely important area for birds and insects. The bird life ranges from buzzards wheeling overhead, to dippers bobbing in the streams. Some of the oldest rocks in England can be found in Church Stretton, and the whole area is renowned for its geological interest. The Stiperstones are of particular importance, a sombre, rock-crowned ridge.

PLANNING

LOCATION
Church Stretton is situated 14 miles (22.5km) south of Shrewsbury on the A49.

HOW TO GET THERE
Church Stretton lies on the A49 which can be reached from the south via the M50, and from the north via the M56. The train station is next to the main road.

WHERE TO STAY
There are plenty of hotels and B&Bs, including the Longmynd Hotel, tel: +44 (0) 1694 722244, www.longmynd.co.uk
I'd recommend holiday cottages such as Botvyle Farm Cottages, tel: +44 (0) 1694 722869, www.botvylefarm.co.uk
For other ideas visit www.heartofengland.com

WHAT TO SHOOT
There are lots of landscapes on offer, including the Long Mynd. Mountain valleys worth exploring include Carding Mill, Light Spout and Ashes Hollow. Look out for charming cottages and wild flower meadows by country lanes.

WHAT TO TAKE
Good walking boots, a sturdy tripod and definitely waterproofs if you are out on the hills. Take a good selection of lenses and filters, including warm-ups and a polarizer.

BEST TIMES OF YEAR
In springtime many woodlands play host to an explosion of bluebells and daffodils. Winter months can offer good opportunities for snow-covered hilltops, while scavenging buzzards can be seen feeding on carrion such as dead rabbits.

ORDNANCE SURVEY MAP
Landranger sheet 137

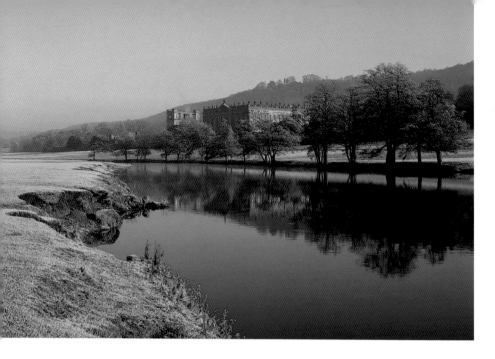

THIS GRAND ELIZABETHAN HOUSE AND GRACEFUL PARKLAND IN DERBYSHIRE IS A MUCH-PHOTOGRAPHED ATTRACTION. BUT IT IS STILL POSSIBLE TO FIND NEW PERSPECTIVES **MARK HAMBLIN**

Chatsworth Park

The principal attraction of Chatsworth Park for most visitors is the impressive Elizabethan house and gardens that stand close to the banks of the River Derwent. The house is a majestic sight that has been well photographed over the years. One of the classic shots is of the bridge bathed in sunshine, with the house beyond. An easy picture to take and one that has adorned countless calendars.

Chocolate-box type scenes of Chatsworth are not something I have dedicated much time to in the past, preferring to look for more natural shots within the park. During the autumn months there can be some spectacular colour on the field maples, beeches and oaks. In winter the park takes on a different mantle. Devoid of leaves, the trees stand like bare sentinels looking down over the secluded house.

Above A shot that avoids cliché, but remains dramatic. The house, while still an important part of the picture, sits in the landscape rather than dominating it. *Pentax 67 with 90mm lens, exposure not recorded, Velvia 50, tripod, spirit level*

Right For several days in December there was high pressure over much of the UK, bringing severe frosts and fog pockets. On this morning, Chatsworth Park was cloaked in fog, the trees heavy with hoar frost. At first visibility was a few metres, but then the fog began to dissipate. This high-key image of a common oak includes a second tree as well as the weak sun. I arrived at an exposure by taking a spotmeter reading from the snow and adding two stops compensation.
Canon EOS1N with Canon 28–105mm lens, 1/30sec at f/16, Velvia 50, tripod

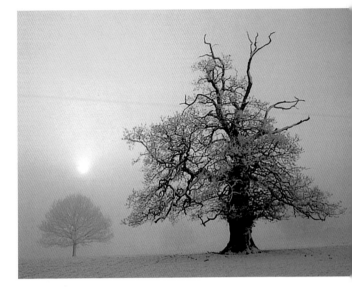

Without the River Derwent, Chatsworth would lose much of its photographic appeal, but the water means that there is a greater chance of interesting atmospheric conditions. Clear winter nights result in frosty mornings and this, coupled with mist over the river, guarantees some photogenic weather. The alder trees that overhang the river often become coated with layers of hoar frost in such conditions, offering potential for classic winter images.

FACTS ABOUT:

Chatsworth Park

Chatsworth House was built in the 16th century and is home to the Duke and Duchess of Devonshire. In the 1760s the Fourth Duke of Devonshire commissioned Lancelot 'Capability' Brown to improve the park. Trees were planted to form belts and the river was widened to form a focal point and to reflect the house. The park has always been a working landscape providing food for the estate. The grass is grazed by sheep, cattle and deer, the river provides fish, and timber is from the woods.

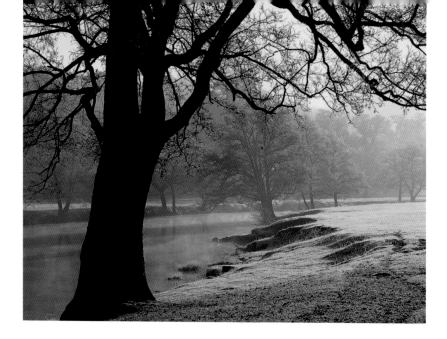

Above Frost, snow, mist and fog all add a dramatic dimension to winter pictures. This view of the River Derwent would barely be worth a second look on a sunny winter's afternoon. But with early morning backlighting and mist over the water, the scene takes on a mystical appearance. I exposed for the bright part of the picture, throwing the dominant tree into silhouette. *Pentax 67 with 90mm lens, 1/30sec at f/16, Velvia 50, tripod*

My only gripe with Chatsworth for much of the year is that the sun is hidden behind a hillside in early morning, preventing sunlit dawn shots. In winter, however, the sun rises much further to the south and consequently clears the hill earlier in the day. In addition, the low angle of the sun during December and January produces a golden light, allowing you to photograph in optimum conditions for longer.

On the morning that I took the main shot (see page 98) I was searching for frosted trees, but wasn't having much luck as the warm sunshine had melted it from the branches. As I turned to head back along the path I was greeted with a view of the house that I hadn't noticed previously. The early sun was illuminating the frosty riverbank and the clear blue sky was reflected perfectly in the river.

What attracted me was the clear, crisp lighting with a hint of frost on the ground. In essence, a landscape that happened to have a big house in the background. Of course, the house was an integral part of the picture and provided the focal point, but it was a subtle representation of a familiar subject.

PLANNING

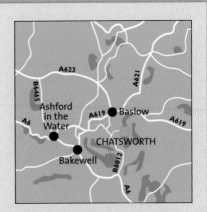

LOCATION
Chatsworth Park is in the Peak District National Park close to Bakewell in Derbyshire.

HOW TO GET THERE
Leave the M1 at Junction 29 and follow the A617 into Chesterfield. Take the A619 west to Baslow and then turn onto the B6012 for Chatsworth. Travelling from the west, take the A6 near Manchester, and then turn onto the A623 near Chapel-en-le-Frith which brings you to Baslow.

WHERE TO STAY
The nearby town of Bakewell has a range of places to eat and stay. Or there are country pubs in local villages. For full details go to www.visitpeakdistrict.com

WHAT TO SHOOT
The house can be photographed from a number of viewpoints using the river or trees to add foreground interest. There are many trees in the park that make good subjects either singly or as part of the wider landscape. Both red and fallow deer frequent the park and can be photographed at dawn.

WHAT TO TAKE
The diversity of subject matter requires a range of lenses from wideangle to telephoto. Waterproof boots are essential.

BEST TIMES OF YEAR
Autumn, winter and early spring are all excellent times of the year. In winter you can shoot all day. Visit www.chatsworth-house.co.uk or tel: +44 (0) 1246 565300 for opening times and more details on the house and grounds.

ORDNANCE SURVEY MAP
Landranger sheet 119

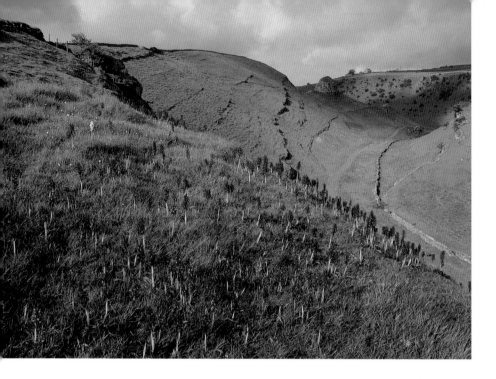

THE WILD PURPLE ORCHIDS OF THE ROLLING LIMESTONE DALES ARE ONE OF THE PEAK DISTRICT'S MOST STRIKING PHOTOGENIC ATTRACTIONS IN LATE SPRING **MARK HAMBLIN**

The limestone dales of the Peak District are well known for their displays of wild flowers during spring and summer. The natural importance of these sites has long been recognized and many have been awarded the status of local nature reserves or Sites of Special Scientific Importance (SSSI). Cressbrook Dale does not actually fall into either of these categories, instead it is managed by English Nature as a National Nature Reserve.

Of the diverse range of plants that can be found at this reserve one stands out a head and shoulders above the rest due to the visual display that can be seen during May. For two or three weeks the slopes of the dale are covered with thousands of brightly coloured early purple orchids. Unlike most of the

Above In order to record all the orchids as sharply as possible, focusing was critical. I made full use of the depth of field afforded by shooting at f/22 and also selected a point of focus about one third of the distance into the orchids.

Pentax 6 x 7 with 55mm lens, 1/8sec at f/22, 1-stop neutral-density graduated filter, tripod

Cressbrook Dale

orchid family, early purple orchids can be very common when growing conditions are favourable, and nowhere is better than at Cressbrook Dale.

A Sunday afternoon walk along the dale alerted me to the fantastic display of orchids on show and so I decided to return the next morning. From my visit the previous afternoon, I had estimated where the sun would rise and figured that I would need to arrive soon after dawn to photograph the orchids. The dale runs east to west towards the prominent focal point of Peter's Stone and is at its best during the morning.

I set off from home in the dark arriving at Cressbrook Dale shortly after sunrise to find the slopes bathed in glorious early morning sunshine. I quickly headed for a section of the dale that held the

Below left After taking a range of pictures showing the orchids en masse, I switched to close-ups of individual spikes. Cloud cover had provided subtle overcast lighting that suited this type of shot. Upon noticing the snail on this flower spike I had no hesitation on which orchid to concentrate. A low point of view and complementary background made the orchid stand out, while Velvia film gave a warm saturated rendition of the vibrant colour of the flower.
Canon EOS1N with 70–200mm zoom and 25mm extension tube, 1/15sec at f/11, Velvia 50, tripod

Cressbrook Dale

Early purple orchids are perennials growing to a height of 6–24in (15–60cm). They are found in grassland, woods and hedges, predominantly on lime-rich soils. The main flowering period is from late April to June, peaking in early May at Cressbrook Dale. They can be very common in suitable habitat, carpeting ground densely. Take great care when attempting to photograph the orchids and be sure not to trample them. Remember to respect your subject.

greatest density of flowers and looked for groups of flowers that made a pleasing composition. Find a position where you can photograph on the edge of a suitable patch of orchids and avoid kneeling or placing camera bags on nearby flowers.

I found some good patches of orchids on the lower slopes but the long shadows from the low angle of the sun made the composition very distracting. I would normally prefer to photograph flowers in soft overcast lighting but I particularly wanted a wide view showing the orchids en masse.

For this shot to work best I had to include the sky and I felt that it needed some colour as opposed to a blanket pale grey. I continued my search until I found a good composition of orchids in a situation from where I could include the backdrop of the dale. By now the sun was beginning to climb and, not wanting to miss the attractive morning light, I got to work.

I began by studying various shooting angles until I settled on a composition that worked well. Everything looked fine except one crucial aberration; a shadow from one of the tripod legs running across the bottom right corner of the frame! Despite my efforts to contort the tripod into a position that would alleviate the problem, the shadow remained and I simply had to wait for the sun to move around.

Expert Advice

Other places of interest: Miller's Dale and Monsal Dale lie to the south of Cressbrook Dale and are both excellent walking/photography country. Lathkill Dale to the south-west of Bakewell is good for early purple orchids. The best displays are at the western end of the reserve. Take the footpath from the B5055 near Monyash.

PLANNING

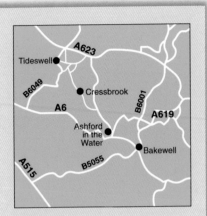

LOCATION
Cressbrook Dale lies in the Peak District National Park, 2 miles (3.2km) to the east of Tideswell.

HOW TO GET THERE
The dale is best accessed from the A623 near Wardlow Mires. From the west take the A623 from the A6 between Buxton and Chapel-en-le-Frith. From the east, exit the M1 at Junction 29 and follow the A617 into Chesterfield. From here take the A619 to Baslow and continue onto the A623. There is a small layby just to the east of the junction with the B6465. A footpath leads along the dale.

WHERE TO STAY
There are numerous B&Bs throughout this part of the Peak District. Tideswell makes a good base for exploring the area. For accommodation listings, contact the Tourist Information Centre in Bakewell, tel: +44 (0) 1629 816558 or go to www.visitpeakdistrict.com

WHAT TO SHOOT
The abundance of early purple orchids. Close-ups of individual flower spikes can be very attractive. There are also good displays of cowslips during late April and early May.

WHAT TO TAKE
A wideangle and a lens for shooting close-ups are a must. A flexible tripod, neutral-density graduated filters and warm-up filters. An angle finder is very useful for low level shots. The bottom of the dale can be wet so you may need wellies. Walking boots at other times.

BEST TIMES OF YEAR
The early purple orchids are usually at their peak during the first two weeks of May. Early to mid-morning is best for flowers en masse in sunshine.

ORDNANCE SURVEY MAP
Landranger sheet 119

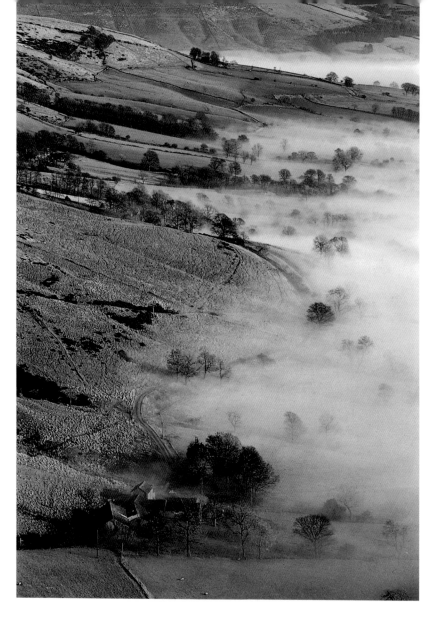

JUST TO THE NORTH OF POPULAR CASTLETON LIES THE WILD, GRITSTONE SCENERY OF THE GREAT RIDGE. THIS IS FORBIDDING TERRAIN WITH A UNIQUE RUGGED BEAUTY **KAREN FRENKEL**

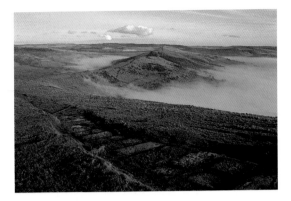

Right Early morning frost glitters on the paved section of the Great Ridge winding its way above the mist in the valleys below. Side lighting from the morning sun shows it at its best. Care was needed, though, as this icy path was lethal!
Nikon F90X with 28–70mm lens, 1/4sec at f/11, Velvia 50, polarizer, tripod

Left View looking north-east below the Great Ridge. Attracted by the farm, trees and S-shaped track winding its way around the orange hillside emerging from the mist, I used a telephoto to crop out the sky and create a more abstract image.
Nikon F90X with 70–300mm lens, 1/15sec at f/11, Velvia 50, tripod

Heaving yourself up the steps from the car park below Mam Tor may seem a pointless exercise until, that is, you crawl out onto the Great Ridge. The spectacular views and great lungfulls of fresh air will soon have you feeling invigorated.

The south-east facing shale cliff face of Mam Tor has a lovely golden glow in the early morning light. Westward are views towards Rushup Edge and the eyecatching sweep of the landslip formations down to the Edale Valley are particularly striking when backlit in the early evening.

Looking northwards, the Kinder Plateau rises from Edale – at its best when the afternoon sun sidelights the valley, picking out its remote farms and settlements among the wilderness. South of the ridge is Castleton, dominated by Peveril Castle and famous for its blue-john caverns – the only place in the world where the precious stone, blue-john, a type of fluorspar, is found. West of the village is the dramatic entrance to Winnat's Pass, a craggy limestone canyon formed 350 million years ago. One of the best views looks north-east along the ridge, with gritstone slabs snaking their way along its crest towards Back Tor.

Admittedly, being close to a tourist honey pot like Castleton can make the ridge a crowded place on a warm sunny day, but the best landscapes are never

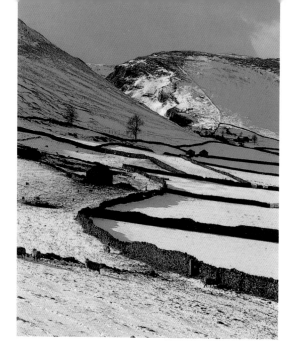

Left I was attracted by the walls sweeping across the snowy landscape to the craggy canyon of Winnat's Pass from Castleton. I used matrix metering and positive compensation for the white snow. It may appear calm, but it was really very blustery. *Nikon F90X with 28–70mm lens, 1/30sec at f/16, Velvia 50, tripod*

taken at these times anyway. For me, the magical time is early on a cold winter's morning when very few (if any) people are around. Cold, clear nights often give rise to mist in the valleys below, particularly the Hope Valley, leaving the Great Ridge rising like a fin above a sea of cotton wool. While Castleton and Edale are buried in cold, grey winter fog, you can be bathed in warm, golden sunlight.

FACTS ABOUT:

The Great Ridge

In the northern heart of the Peak District, the Great Ridge stretches for 2 miles (3.2km) between Mam Tor 1,696ft (517m) and Lose Hill 1,561ft (476m), with the shale face of Back Tor in between. It lies on the border of the White Peak and Dark Peak with limestone Castleton to its south and the gritstone settlement of Edale to the north. Owned by the National Trust, Mam Tor is also known as the Shivering Mountain, due to the unstable layers of grit and shale.

PLANNING

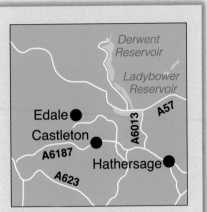

LOCATION
The Great Ridge runs from south-west to north-east between Castleton and Edale in the Peak District National Park.

HOW TO GET THERE
From the east, take the A625 to Castleton and follow signs to Winnat's Pass. At top of pass turn right onto the B6061 until you come to Mam Tor car park on the right, just before the Edale turnoff. Steps lead up out of the car park to the road above, bear right to the top of Mam Tor. From the west, take the A625 eastwards from Chapel-en-le-Frith, where the car park is beyond the Edale turning, on the left-hand side.

WHERE TO STAY
For listings of accommodation, contact the national park information centres in Castleton, tel: +44 (0) 1433 620679 or Edale tel: +44 (0) 1433 670207. Alternatively, for further ideas, go to www.visitpeakdistrict.com

WHAT TO SHOOT
Cliff face of Mam Tor, views down the Edale Valley and across to Kinder, and much more.

WHAT TO TAKE
Full range of lenses, tripod, polarizer, filters. Weatherproof clothing, walking boots and food.

BEST TIMES OF YEAR
Autumn and winter are best for the light quality. Sunrise to late morning are the best times for photographing the ridge and Mam Tor. Afternoon to sunset for Edale valley and shots of Rushup Edge.

ORDNANCE SURVEY MAP
Landranger sheet 110

Kinder Scout

THE HIGHEST POINT OF THE REGION, KINDER SCOUT LIES IN THE HEART OF THE DARK PEAK AND IS A HAVEN FOR HILL WALKERS, BIRDWATCHERS AND PHOTOGRAPHERS ALIKE **GEOFF SIMPSON**

I often find myself gazing out of the window across the farmland and villages of Birch Vale and Hayfield to the distant, dark massif of Kinder Scout. Situated in the Dark Peak, between the cities of Manchester and Sheffield, Kinder Scout remains a firm favourite with thousands of hill walkers each year. The plateau, at 2,088ft (636m) above sea level, represents the highest point of the Peak District National Park. It is a wild and relatively featureless plateau which is important in terms of nature conservation, primarily due to the expanse of high altitude blanket peats and the assemblage of flora and fauna that survive there.

Overgrazing and pollution have degraded the flora of Kinder. Cotton grass, bilberry, crowberry and the occasional outcrop of heather and cloudberry now carpet the eroded plateau. The red grouse, a subspecies of the European willow grouse, feeds almost exclusively on young heather shoots. Golden plover, ring ouzel, wheatear, meadow pipit, skylark and the dunlin all breed on Kinder.

Above I disturbed a party of half a dozen or more hares as I walked across the open moorland towards the Kinder plateau. One hare, in its confusion, remained still, allowing me a relatively close approach.
Canon EOS1N with 300mm lens, 1/15sec at f/5.6, Sensia 100, mirror lock-up, tripod

Above Overnight snowfall and a clear sky can transform Kinder into a winter wonderland – on this occasion I didn't see a single mountain hare despite literally hundreds of tracks crisscrossing the snow. I waited until the sun began to sink and closed in on this single line of tracks with the plateau as a backdrop.
Canon EOS1N with 24mm lens, 1/6sec at f/16, Velvia 50 rated at ISO 40, mirror lock-up, tripod

The mountain hare, or blue hare as it is sometimes referred to, was introduced to the Dark Peak from Scotland during the 19th century. Despite introductions to Snowdonia and the Brecon Beacons, this fragile population remains the only one outside of Scotland to have survived. As numbers gradually decline, they hang on – without any protection.

The mountain hare is a specialist mammal of high altitudes, changing colour from brown in summer to white with black tips to its ears and nose in winter.

There are several tried and tested methods you can use to obtain images of mountain hare – stalking is one approach I find that works, particularly when you are working with ample cover. But my favourite approach is to simply sit and wait. Mountain hares use traditional routes across the plateau so I find a large boulder, which acts as cover, while I wait and see what passes by.

Left There are several places in Britain where it is possible to use a car as a roadside hide to photograph red grouse – but Kinder Scout is not one of them! So to get this shot without any form of cover was a delight. *Canon EOS1N with 300mm lens and 1.4x converter, 1/45sec at f/6.3, Provia 100, beanbag*

Expert Advice

Photographers who want to capture the remoteness of the Pennines will find Kinder Scout hard to beat. The best scenes are located around the edges where the rocks are exposed.

FACTS ABOUT:

Kinder Scout

Kinder Scout is famously known for its mass trespass, which occurred on April 25th 1932, when between 400 and 500 ramblers trespassed on Kinder Scout as a protest for the freedom to roam. Off the beaten track, lies Mermaid's Pool, surrounded by folklore. The Celts believed that pools of water were portals to the 'other world' and sacrifices were often made in stretches of water such as this. Today 'water worship' continues in Derbyshire in the form of 'well dressing' each summer.

PLANNING

LOCATION
Kinder Scout lies next to the A57, known as the Snake Pass, between Manchester and Sheffield.

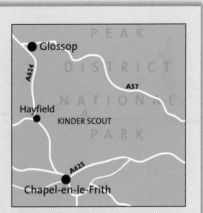

HOW TO GET THERE
There are three main routes on to Kinder Scout. From Glossop take the A57 and, having parked your vehicle at the summit of the Snake Pass (limited roadside parking), a track to the right takes you across Featherbed Top with the plateau of Kinder Scout clearly visible ahead. From the nearby Hayfield, follow the Kinder Road past Kinder Reservoir and the Mermaid's Pool on to Kinder. This is the original route taken by the famous mass trespass in 1932. A favourite way on to Kinder is to take the Jacob's Ladder path from the village of Edale, which forms the start of the Pennine Way if heading north.

WHERE TO STAY
There are many hotels in nearby Buxton and the Peak District market towns of Bamford and Hathersage. For more information go to www.visitpeakdistrict.com

WHAT TO SHOOT
Kinder Downfall is a waterfall worth the effort of locating, as the wind can often blow the water back up into the air making for dramatic images. During periods of extreme cold the downfall often freezes up and is frequently used by ice climbers. Mountain hares will certainly test your patience and stalking skills, but are well worth the effort.

WHAT TO TAKE
A wide range of lenses from 24mm for those sweeping landscapes, macros for close-up lichens and mosses and long telephotos for mountain hare and red grouse.

ORDNANCE SURVEY MAP
Landranger sheet 110

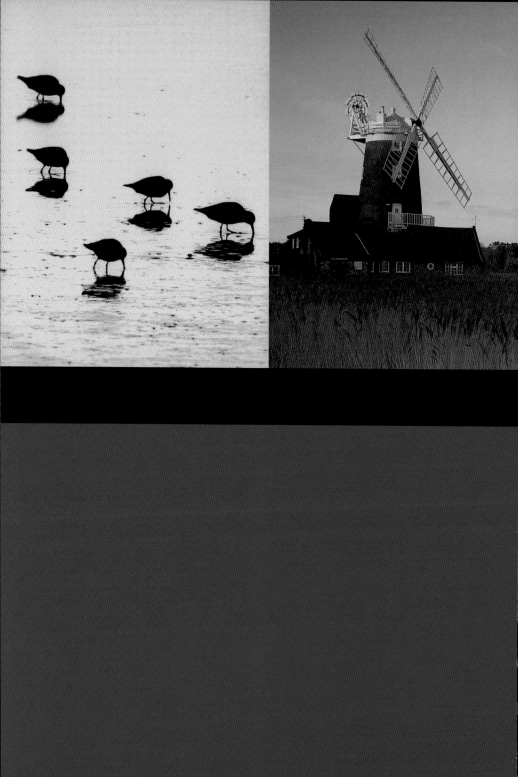

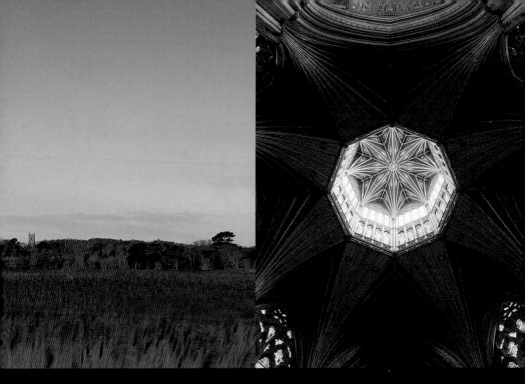

PART FIVE **THE EAST**

DOMINATED BY A WINDMILL AND CHURCH, THE HISTORIC TOWN OF THAXTED IS PARTICULARLY ATTRACTIVE, WITH FINE TIMBER-FRAMED BUILDINGS AND MUCH CHARACTER **CRAIG ROBERTS**

When I was asked to photograph Essex for a magazine, showing its finer points, I was intrigued, having never been to the county before. I was pleasantly surprised that it has some lovely old buildings and castles, and the small towns dotted around are most picturesque. I also discovered the

Below I don't like tilting the camera up to shoot buildings, but maybe because of their shape, windmills are a little more forgiving. The wheat field fills the foreground with its warm colour.
Mamiya RZ67 with 50mm lens, 1/8sec at f/32, Velvia 50, polarizer and 81B warm-up filter

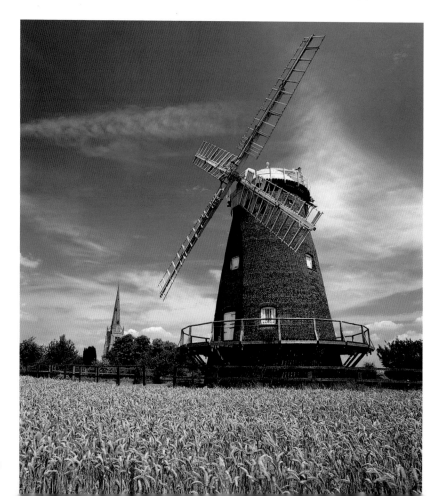

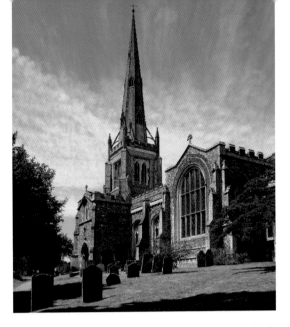

Above right After the
windmill shot was in the
bag, I moved on to shoot
the church, which
thankfully also looked
its best with afternoon
light. My 75mm shift lens
was just right to frame
it, while at the same
time keeping the
verticals straight.
*Mamiya RZ67 with 75mm
shift lens, 1/15sec at f/16,
Velvia 50*

muddy estuaries that cut into the Essex coast, which
provided several opportunities to capture both the
sunrise and sunset. As well as searching for ideal
places myself, I had been given a list of places they
definitely wanted featured and the small country
town of Thaxted was near the top of the list.

On arriving in Thaxted, I had planned to make my
main view of the town in Stoney Lane, which features
a very white-looking Guildhall at one end, together
with old timber-framed buildings on one side, leading
up to the church. It was a shot I had seen previously
in a guidebook and seemed to sum up the town
nicely. However, it all looked very modern when I
arrived, with parked cars all the way up the street
spoiling the perfect view. Undeterred, however, I
decided to take my chances with the old windmill
instead and headed up the lane.

As this was my first visit to the town, I hadn't had
the chance to pre-visit the windmill to determine the
best time of day to photograph it. I was on a pretty
tight schedule so it was with relief, therefore, that I
approached the windmill and saw the perfect
composition appearing before me.

Thaxted

Thaxted is a small county town with a recorded history dating back to before the Domesday Book. It remains today as it has been for the last ten centuries and originally developed around a Saxon settlement, built alongside a Roman road. John Webb, a local farmer and landowner, built the windmill in 1804 to satisfy the increasing demand for flour both locally and in London. It has been superbly restored to working condition and contains a rural life museum.

Expert Advice

You can probably get away without a tripod for the street views, which also means you're less likely to get in anyone's way. Take one up to the windmill though, so that you can use the full depth of field on your wideangle lens, without worrying about shutter speeds.

It was now early afternoon and the sun was starting to shine on the far side of the mill. I was in luck, as a morning shot wouldn't have worked as well. As I walked round the mill, it all started to come together. I had the wheat field in the foreground, adding a splash of colour, and the sun was just in the right position to allow me to use a polarizing filter and bring out those wispy clouds. The windmill was looking splendid and, to top it off, you could just glimpse the church in the background.

I first tried viewing the scene through my 75mm shift lens, but keeping the camera straight, and with the lens at its maximum adjustment, I couldn't get the top of the sails of the windmill in shot and I was losing too much foreground as well. So instead, I fitted a 50mm lens to the camera and tilted up slightly, which obviously meant getting some converging verticals. But it was not enough to worry about on this occasion and I even think it adds to the shot, especially the way the sails are pointing to the top right corner of the frame. For some reason I find windmills are more forgiving to this technical faux pas – perhaps it has something to do with their triangular shape. Overall, I was very pleased with the composition of the picture.

PLANNING

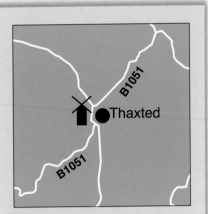

LOCATION
Thaxted is in the north-west part of Essex – very close to Stansted Airport and 19 miles (30.5km) north of Chelmsford.

HOW TO GET THERE
The nearest motorway is the M11, which you leave at Junction 8 (Stansted Airport), joining the A120 to Great Dunmow, then the B184 to Thaxted.

WHERE TO STAY
Try the Farmhouse Inn, tel: +44 (0) 1371 830864. Or the Crossways Guest House, tel: +44 (0) 1371 830348, www.crosswaysthaxted.co.uk For other information and listings go to www.visiteastofengland.com

WHAT TO SHOOT
As well as the windmill, there is the parish church and Stoney Lane, which leads up to the church and is well worth getting a shot of. Watling Street also has some fine timber-framed buildings.

WHAT TO TAKE
A wideangle lens and a shift lens if you have one.

BEST TIMES OF YEAR
I have seen shots of rape growing around the windmill, so late spring may provide a splash of yellow to your shot of the mill as well.

ORDNANCE SURVEY MAP
Landranger sheet 167

LYING JUST NORTH OF CAMBRIDGE, ELY MAKES A DELIGHTFUL
BASE TO TOUR THE AREA AND IS HOME TO ONE OF THE MOST
SPECTACULAR CATHEDRALS IN THE COUNTRY **DEREK FORSS**

It is well known that landscape photography is governed by the quality of light the same is true when photographing cathedral interiors. Instead of relying on sophisticated photographic equipment for exposure, I work with light by using my eyes. For church interiors I prefer this 'back to basics' approach. The importance of seeing light with the naked eye and how it translates to the final shot is paramount inside a cathedral or church. The aperture and shutter speed I use, or even the film and camera, are secondary to 'reading the light', and only experience can tell you what will work.

Above Church ceilings photograph best in winter months when the angle of light is much lower. In summer the interior is rendered shadowy and very difficult to expose for by the high sun. *Hasselblad 500CM, 1sec at f/4, Velvia 50, tripod*

Right The Lantern is the single feature that distinguishes Ely Cathedral architecturally. Because of high contrast it is not easy to photograph and some bracketing may be necessary. Later in the day the lighting is softer and at dusk it is illuminated.
Hasselblad 500CM with 80mm lens, 1sec at f/4, Velvia 50, tripod

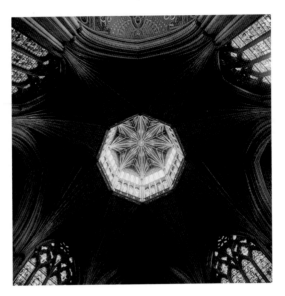

On entering Ely, the fine detail of the nave ceiling, hidden by the apparent gloom, is invisible to the naked eye. I have been told that it takes 20 minutes for the human eye to adjust, and that has been a good yardstick since. But in either case a photograph will 'see' more, and this is one of the first things you learn when photographing church interiors.

FACTS ABOUT:

Ely Cathedral

The construction of Ely Cathedral was begun in 1081 under the guidance of Abbott Simeon. It was completed in 1189 and now stands as a fine example of Romanesque architecture. Considered the most outstanding feature of the cathedral, the Octagon was built to replace the Norman tower which collapsed in 1322. In the 14th century the Lady Chapel was added and, with its intricate carvings, it is the largest in England. Most cathedrals allow photography outside service hours for a fee. For hours of opening, tel: +44 (0) 1353 667735 or go to www.eastofengland.com

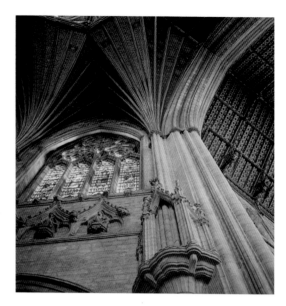

Right Balancing the exposure of stained glass with an interior wall in natural light is difficult. Two important factors help – a dull day and glass of dark hues. *Hasselblad 500CM with 80mm lens, 1sec at f/4, Velvia 50, tripod*

Expert Advice

I prefer the winter months for this kind of photography as the level of light is lower with fewer problems related to contrast – there is also a relative absence of people. Even with the camera fixed to the tripod, camera shake can occur when the mirror flips up.

It is widely known that even the finest film emulsions have their limitations, but when it comes to low light, a film records more than the human eye perceives.

Essential, of course, is a tripod. It needs to be pretty sturdy so that it doesn't shake when using a long shutter speed with a powerful telephoto. Artificial light is a dilemma, particularly when the composition mixes it with daylight. I stick with daylight film, preferring to run the risk of warming the colours, admittedly quite unnaturally.

My camera does not have a coupled exposure meter. This 'limitation' taught me to read the light with my eyes, admittedly with the help of a general reading from a separate exposure meter first, but it also taught me to use my 'wit' when judging a shot.

Another matter to address is depth of field. Use the hyperfocal distance – focus at infinity and note the closest point that is sharp at a particular aperture. Then refocus on this point in order to allow the greatest possible depth of field.

PLANNING

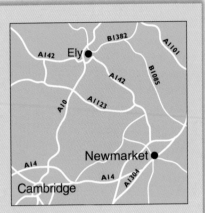

LOCATION
About 15 miles (24km) north of Cambridge.

HOW TO GET THERE
By car, take the A10 from the A14. By train, London Kings Cross to Kings Lynn service, trains also from the Midlands.

WHERE TO STAY
The town centre offers numerous options for refreshment and overnight accommodation, but don't overlook the refectory within the cathedral for delicious homemade cakes. Contact the Ely Tourist Information Centre for more details, tel: +44 (0) 1353 662062 or go to www.visiteastofengland.com

WHAT TO SHOOT
The highlights are:
the nave ceiling, Lantern and Bishop Alcock's Chantry.

WHAT TO TAKE
Tripod essential, plus a range of lenses from 24mm to at least 200mm (in 35mm) for detail. It is great if you can get hold of an image shift lens.

BEST TIMES OF YEAR
Any time of year but remember you are governed by opening times. Don't break for lunch when others will. You can then often have the place to yourself.

ORDNANCE SURVEY MAP
Landranger sheet 143

THE SIMPLE CHARM OF SUFFOLK COMES TO LIFE IN SOUTHWOLD, DOTTED WITH THE STRIKING SHAPES AND JAUNTY COLOURS OF BEACH HUTS AND FISHING BOATS **GARY HACON**

Southwold holds many diverse areas of interest for the photographer, so with each visit it is worth deciding beforehand which element to concentrate on. The town is a bustling centre for local people and visitors alike, with an array of quaint shops, and it is rich in architecture with many well-maintained buildings. The lighthouse, standing high above its neighbours, is painted brilliant white, and nestles among pretty cottages on the clifftop. Moving south from the lighthouse, one comes across the coastguard lookout and a row of old cannon pointing out to sea, still posing a defence from times past.

Down on the promenade you are met with the sight of dozens of smart beach huts, all different colours and named individually by their owners. At sunrise there is nothing between these huts and the morning light. Viewed from the beach they stand side by side with the cliffs rising up behind and the rooftops of the town above breaking the skyline. Walking along the shingle beach and sand dunes to the south of the town brings you to the mouth of the

Above These are just three of the brightly coloured beach huts that sit on the lower promenade of Southwold's seafront. The colours, shadows and repetitive patterns always make them an appealing subject. A polarizing filter was used to make the most of the contrast between huts and sky. *Nikon F90X with 24–120mm lens, exposure details not recorded, Sensia 100*

River Blyth. This is the source of many photographic opportunities. From the car park, an unsealed road heads inland for approximately half a mile (0.75km). To the right of this road are numerous old black painted fishing huts from which the local fishermen sell fresh fish. To the left is the river, which has several wooden landing stages, some on piles, some floating. These landing stages provide mooring for numerous boats, both local and visiting. Their type, colour and condition provides an endless supply of images. Several of these craft are sitting at the water's edge rotting away, showing off their wonderful texture and construction with rusting metal and peeling paint in abundance. To capture the boats at their best, early mornings and late afternoons are most favourable.

At the end of the dirt road there is a pub, and the road cuts right across a sluice, over Reydon Marshes and back to town. Beyond the pub, a small footbridge crosses the river, giving access to the village of Walberswick. From the footbridge, the view inland leads to a disused windmill, minus its sails, and beyond are Reydon Marshes. The sun sets along this section of the river, giving good reflections of the evening skies. Those interested in birds will also have much to see. On our last visit, we watched a marsh harrier wheeling above the reedbeds.

Right This beach hut stood out because of its wonderful colour. It was so striking against the blue sky. As a graphic image it was really appealing to me. *Nikon F90X with 24–120mm lens, exposure details not recorded, Sensia 100*

THE MANOR HUT

222

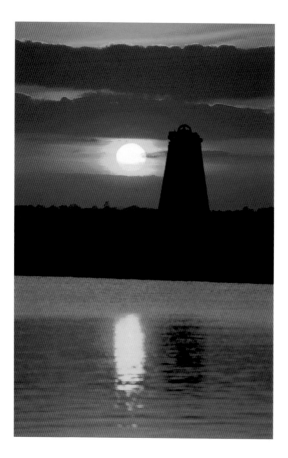

Left Sunset looking west along the River Blyth, near the footbridge to Walberswick. Taken on a summer's evening, the grasses were alive with mosquitoes, which were very hungry! Metering from the grass around me controlled the exposure. I find this method most reliable in almost every case. *Nikon F90X with 24–120mm lens, exposure details not recorded, Sensia 100*

Southwold

This is a pretty Suffolk seaside town with enough charm and interest to satisfy almost anyone. With its lighthouse, beach huts and river dotted with watercraft, this area provides a wealth of interest for the photographer. Largely unspoilt by modernization, Southwold has managed to retain its character and provides a glimpse of life as it once was. Away from the seafront, there is a market place, an interesting town hall, museum and the UK's only amber museum. Expect to see plenty of birdlife in the area, too.

PLANNING

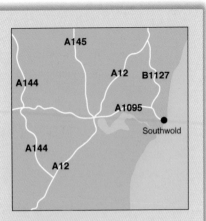

LOCATION
Southwold is on the east coast of England, in the county of Suffolk.

HOW TO GET THERE
Take the A12 between Ipswich and Lowestoft. At Blythburgh take the A1095 towards Southwold. Parking is readily available and often free.

WHERE TO STAY
Being a seaside location, there is no shortage of accommodation. For listings, contact the Southwold Tourist Information Centre, tel: +44 (0) 1502 724729 or go to www.visitsouthwold.co.uk

WHAT TO SHOOT
Architecture in the town, beach huts on the prom, sand and stone patterns on the beach, boats on the river and sunsets/sunrises over the marshes.

WHAT TO TAKE
Prepare for the English weather; a tripod is a must; insect repellant and good footwear.

BEST TIMES OF YEAR
This is a great location at any time of year.

ORDNANCE SURVEY MAP
Landranger sheet 156

Cley Windmill

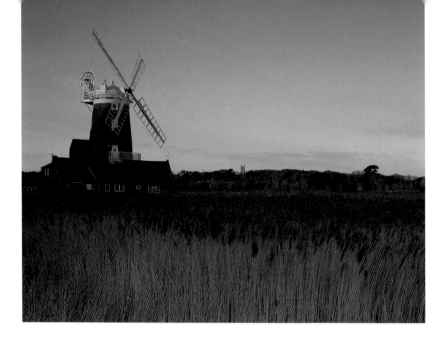

ON THE WINDSWEPT NORFOLK COAST, 18TH-CENTURY CLEY WINDMILL IS A WELL-KNOWN LANDMARK THAT HAS INSPIRED MANY ARTISTS AND PHOTOGRAPHERS **ANDREAS BYRNE**

I climbed out of my nice warm car into a bitter easterly breeze. Nice wake-up call, I thought to myself. I zipped up my fleece and windproof jacket, put on my thermal gloves and hat then donned my rucksack and picked up my tripod before making my way along the footpath towards the windmill.

I didn't have far to go before coming across this view. I found some steps that led up to a grassy bank and thought this would be an ideal spot to take a photograph as it gave me an elevated view across the reeds towards the windmill. When I view a potential picture I like to look through the viewfinder, moving the camera up and down, vertically and horizontally, to see which is most pleasing to the eye. I also try various lenses as this can create an entirely different picture without moving from my spot. In this case a wideangle lens could be used to include more sky

Expert Advice

In the background of the picture above you can see that Blakeney church and the surrounding trees have all been lit up by the rising sun. This is because they are on a small hill; the sun wasn't high enough to light up the reedbed, which gives the shot more depth. It also meant that I would be using a graduated neutral-density filter.

Left Cley windmill at about 7.45am on a cold breezy morning looking from the east. I like the movement of the reeds caused by the breeze and an exposure time of two seconds. I used two neutral-density graduated filters to balance out the brightness of the sky with the land.
Pentax 67 with 55–100mm lens, 2secs at f/22, Velvia 50, 2 neutral-density graduated filters, tripod

and a telephoto lens could be used to emphasize the windmill. I used my 55–100mm zoom (approximately 28–50mm in 35mm format) at 100mm as this gave me a good-sized windmill with enough of the surrounding landscape.

I set up my tripod and decided to have it at ground level as the wind was gustier on the grassy bank. I crouched behind my camera, shielding it from the wind and to help stop any camera shake. To balance out the shady reeds from the bright sky and sunlit background a graduated neutral-density filter was needed, so I took a metered reading from the reedbed excluding the sky and used the given settings as a starting point.

I knew from past experience that the metered reading would probably not be correct as the reeds, being light in colour, would fool the meter into giving a faster shutter speed than was necessary, thereby underexposing the shot. The best thing for me to do was to bracket my exposures. I took the camera's metered exposure settings just to prove to myself that it was incorrect. This was a little test for myself and I find it's the best way to learn from one's mistakes. I would rather use up six or eight exposures if I'm not sure of the metering, this way I should get at least one decent shot.

Cley

FACTS ABOUT:

Cley (pronounced 'Cly') next the Sea was once a thriving port. The windmill was built in the early 18th century and is situated on the River Glaven, and it has been featured in many paintings and photographs. The windmill today is a B&B. Cley marshes are a haven for bird life. The reedbeds at Cley support a large amount of migrant birds and wildfowl. The reserve is noted for rarities such as yellow browned warbler, wryneck, spoonbills and bee-eaters. It is ideal for birdwatchers.

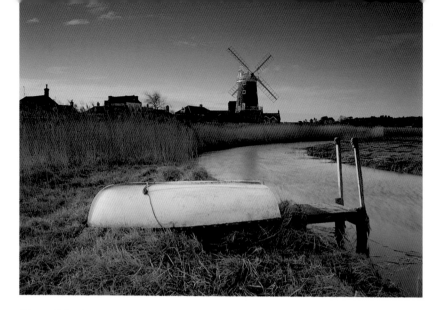

Above This photo was taken from the north-east and shows an upturned rowing boat in the foreground. The river leads the eye towards the windmill with the village in the background, the sun was a bit higher in the sky and has just started to hit the reeds. *Pentax 67 with 55–100mm lens, 1sec at f/32, Velvia 50, tripod*

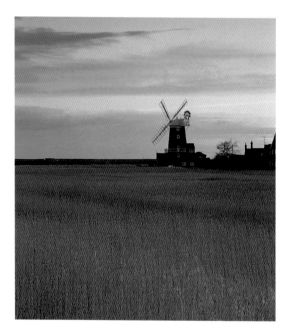

Left This photo was taken from the west looking east; I waited in my car for ten minutes before the sky started to go pink then I got out and set up my camera and tripod. I used a 165mm lens to isolate the mill from the village. *Pentax 67 with 165mm lens, 1/8sec at f/8, Velvia 50, 3-stop neutral-density graduated filter, tripod*

PLANNING

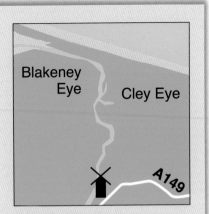

LOCATION

Cley next the Sea is situated on the North Norfolk coast between Sheringham and Blakeney.

HOW TO GET THERE

From Norwich take the A140/A149 to Cromer, then stay on the A149 coast road to Cley.
From King's Lynn take the A149/A148 then turn off on to the B1156 to Blakeney. Buses run from Cromer. Cley is approximately three hours from London.

WHERE TO STAY

You can stay at the windmill as it's a B&B. The Mill, tel: +44 (0) 1263 740209, www.cleymill.co.uk
There are a number of other hotels and restaurants in the village.
For more information go to www.visiteastofengland.com

WHAT TO SHOOT

The windmill is the main attraction, best at dawn and dusk. A huge variety of bird life. The flint village with all its listed buildings.

WHAT TO TAKE

All the usual camera gear and tripod, warm, windproof clothing, some good walking boots.

BEST TIMES OF YEAR

Summer time brings more people but the sun will hit the windmill face on at dawn and the reeds will be green.

ORDNANCE SURVEY MAP

Landranger sheet 133

DISCOVER THE ISOLATED BEAUTY OF THIS NORTH NORFOLK VILLAGE, INCLUDING THE SALTMARSHES, PRETTY HARBOUR, BIRD LIFE AND SEALS **ROS NEWTON & MARK HICKEN**

My partner, Mark Hicken, and I had just arrived in Norfolk after two days travelling from the north of Scotland. The north Norfolk coast is picturesque and although we had visited many times before it was generally as birdwatchers – this time the emphasis would be on photography.

The attractive north Norfolk village of Blakeney is situated on a tidal creek running through saltmarsh, the focal point of the village is the quay. Here, a myriad of sailing dinghies and motor boats moor up, dependent on the tide for access to the waters of Blakeney Haven and the North Sea. Nearby, an embankment provides access to the saltmarsh and a large expanse of mudflats.

Next morning, as the tide turned, we were in position, watching waders probing the exposed mud. The indeterminate plumage of the birds at this time of year encouraged us to think in terms of silhouettes and, consequently, we were shooting virtually into the sun. Many good photographs can be ruined by lens flare, so care had to be taken.

Above Although not the best way to approach or photograph seals, a trip to Blakeney Point is irresistible on a good day. I found standing in the middle of the boat rocking against its motion the best way of achieving a shake-free shot of a static group of seals. *Nikon D100 with 300mm lens, 1/800sec at f/11, ISO 200*

Blakeney

In 1086 Blakeney appears in the Domesday Book as Snitterley (both names derived from the Saxon/Anglo-Saxon word for 'Black Isle'). Why the name changed is not known. Throughout its history Blakeney was an important port for fishing and trade, so much so that Richard II exempted 'the fishermen of Blakeney, Cley, Cromer and the adjacent ports' from being taken into the King's service. As the harbour silted up, trade decreased and now Blakeney exists as a small holiday resort.

The reddish-orange glow of the dawn light reflecting off the surface of the mudflats accentuated the dark shapes of a small group of dunlin feeding nearby. The shot was there, but a little patience was necessary. A good picture isn't only about light and subject, but also position. This can be difficult with wildlife but, by careful observation and anticipation of their movement, a good composition can be obtained.

We opted to spend the rest of the day around the quay. As time wore on the scene changed constantly providing countless opportunities. Towards evening

Below This is probably the classic shot of Blakeney Quay – looking past the moored boats to the Blakeney Hotel from the west. Catching the last rays of sunlight creates a soft, warm feel. *Nikon D100 with 18–35mm lens, 1/2sec at f/22, ISO 200*

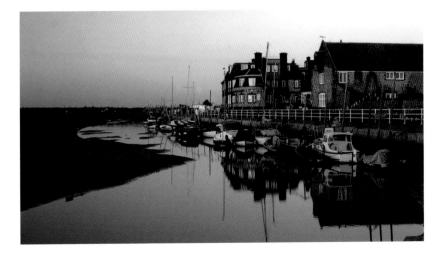

Above As the plumage of most waders changes to a cryptic grey-brown in autumn, an unusual approach was required. In silhouette the colours, or lack of them, are irrelevant and the birds show well against the rich reflected colour of the morning sun.
Nikon D100 with 500mm lens, 1/100sec at f/22, ISO 200

the soft light of the fading sun picked out the colour of the boats and gave the quay a different feel. Having chosen the shot we set up our gear. Even in windless conditions, it's important to use a tripod to give maximum stability when using slow shutter speeds.

The next day we went on a boat trip to see the seals. Photographing anything from a boat can be tricky, but calm water, a secure position in the middle of the craft and good light gave us the opportunity for several shots. A fast shutter speed was essential to overcome movement due to a handheld camera and the swell of the boat. The timing of the trip: 11.30am on a sunny, late summer's day was not a good time, as the high, strong sunlight creates heavy shadow and overly contrasting images. Spot metering off the lighter grey of the seals prevented overexposure of their wet skin, and offered a reasonable balance between deep-blue sea and light reflective sand.

Working a location over several days makes sense. A stroll around the village brought its own rewards – narrow streets with cobblestones and red slate cottages, the beautiful church of St Nicholas and the Grade II listed Kings Arms public house. Our last evening was spent in the 'Kings' reflecting on what we had achieved and what to shoot next time.

PLANNING

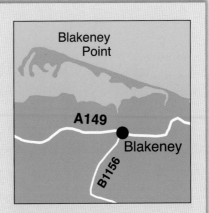

LOCATION
Blakeney is near Holt in Norfolk.

HOW TO GET THERE
From King's Lynn take the A149 coast road towards Cromer. Alternatively, from Norwich take the A140 to Cromer, then the A149 in the direction of King's Lynn.

WHERE TO STAY
The King's Arms in the village offers B&B or self-contained flatlets, tel: +44 (0) 1263 740341. There are also guest houses and three hotels in the area.
For more information go to www.visiteastofengland.com

WHAT TO SHOOT
Harbour scenes, boats, birds, architectural detail, the village, the church, sunsets, reflections.

WHAT TO TAKE
Comfortable waterproof footwear, wideangle and telephoto lenses, tripod, polarizer.

BEST TIMES OF YEAR
Late summer for saltmarsh plants such as sea lavender and sea aster, which attract numerous butterflies and day-flying moths. Autumn for migrating birds. In winter flocks of brent geese frequent the area. Early mornings and evenings are better for photographs, when there are fewer people around.

ORDNANCE SURVEY MAP
Landranger sheet 133

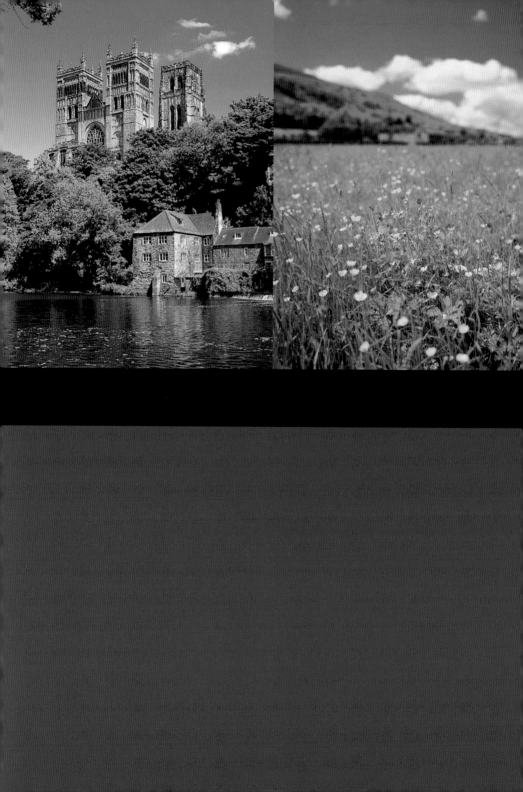

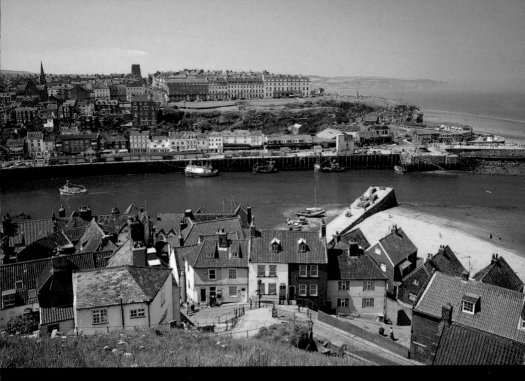

PART SIX YORKSHIRE & THE NORTH-EAST

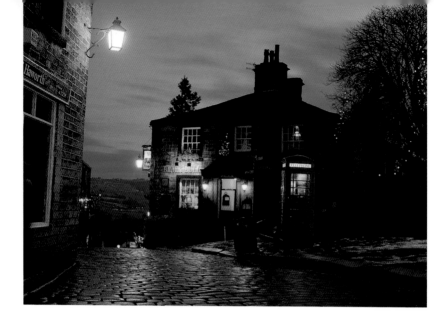

HAWORTH HAS A WARMTH AND NOSTALGIC CHARM TO CONTRAST WITH THE BLEAK MOORS THAT ENVELOPE IT – WHICH SO INSPIRED THOSE FAMOUS RESIDENTS, THE BRONTËS **ROY HAMPSON**

Haworth probably hasn't changed much since 1820, when the Rev Patrick Brontë went to live in the parsonage (now a museum) along with his wife and six children. His three gifted daughters were Charlotte, Emily and Anne, all of whom wrote novels that are now regarded as classics. Their brother Branwell was just as talented, but was an alcoholic. Haworth is also the setting for the memorable television advert for bread, which featured the classic Yorkshire image of a young lad dressed in flat cap, breeches and braces, pushing a bike up a steep cobbled street. This is Haworth, and he may have been delivering to the Black Bull Inn, which is situated almost at the top of Haworth's main street, next to the church. I have visited Haworth many times, and always loved the scene – the red phone box and a peek at the distant rolling hills, between the apothecary shop and the Black Bull Inn.

Above The Black Bull Inn at dusk. The best time to photograph Haworth Main Street is during the week when few tourists are about. The cobbled streets come to life when it is wet. This shot was taken at about 4pm to capture that blue sky. The Christmas decorations (even in November!) added to the scene.
Bronica ETRSi with 80mm lens, 4secs at f/4, Velvia 50, tripod

Converting all this onto a piece of film, I was soon to discover, can be quite a challenge, and many of my attempts to photograph the Black Bull during daylight hours only produced average results.

I went there one wet November day at about 4pm in the afternoon, at dusk. I felt very excited at the quite brilliant scene to photograph before me. It was almost dark and the glimmering street lamps were illuminating my favourite view. Christmas decorations were already in place, adding even more colourful lighting to the scene. The windows of the shop and the Black Bull were lit and so was the phone box. The cobblestones were wet and glistening, reflecting the light. Although it had been a cloudy grey November day, the sky itself was now rendered a deep blue.

This scene was difficult to capture. It's the almost-black stone buildings that create the problem. They don't reflect any light on the surface, so the secret was to shoot when the sky was just light enough to

Below The old apothecary shop situated opposite the Black Bull Inn. The lady who ran the shop arranged for me to do the photography when the shop was closed. I didn't add colour correction filters, hence the nostalgic orange glow.
Bronica ETRSi with 80mm lens, 4secs at f/8, Velvia 50, tripod

Left Blame global warming, but I have tried for years to capture this scene in snow. It's situated on the Brontë Waterfall footpath. A frosty late morning is the nearest I can manage. For winter sunshine to light up this scene you have got to shoot at midday – after this the sun disappears behind a steep hill on the left of the farm building. *Pentax LX with 50mm lens, 1/30sec at f/16, Velvia 50, neutral-density graduated filter and 80A warm-up filters, tripod*

show the outlines of the buildings, but not too light to swallow up the dim artificial light. You have only a few minutes of photography a day. I never add colour correction filters during night-time photography – I enjoy the colour casts artificial light can create on daylight film, the greens and warm orange tones that vary depending on the type of lighting available.

FACTS ABOUT:

Haworth

Haworth is a small industrial town in the Worth Valley. It's a bleak place surrounded by moorland. To the west of Haworth are Brontë Falls, then further down the footpath you will find Top Withins, the setting for the novel *Wuthering Heights*. Ponden Hall is Thrushcross Grange from the same novel. For information about the Brontës go to www.bronte.org.uk From Top Withins and Haworth Moor are fine views of Airedale and the surrounding countryside. At the bottom of Haworth's main street is the Worth Valley Railway, and steam trains can be seen puffing up the valley from Keighley to Haworth, ending up at Oxenhope. The railway has been featured in many films, including *The Railway Children* and *Yanks*.

PLANNING

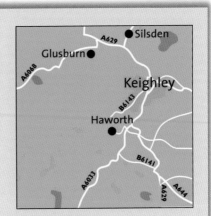

LOCATION
Haworth is situated on the main A629 road from Halifax to Keighley in West Yorkshire.

HOW TO GET THERE
By car take the M62, and head for Halifax, then take the A629 to Haworth. Or you can catch a train to Keighley from Leeds, then there is a regular bus service to Haworth, only 2 miles (3.2km) away. Travel by steam train (Worth Valley) from Keighley railway station to Haworth at weekends.

WHERE TO STAY
Try the famous Black Bull Inn, tel: +44 (0) 1535 642249, wwwtheblackbullhaworth.co.uk, or the Old White Lion, tel: +44 (0) 1535 642313, www.oldwhitelionhotel.com For other options, go to www.yorkshirevisitor.com

WHAT TO SHOOT
Cobbled Main Street, church and churchyard. Worth Valley railway. Open moorland, dry stone walls, sheep, tumbled-down farm buildings and Brontë Falls.

WHAT TO TAKE
A sturdy tripod for night-time/low light shots. A 50mm lens will cover most photographic possibilities but a 200mm is handy for landscape work. A pair of wellies for walking along the footpath to Brontë Falls and Top Withins.

BEST TIMES OF DAY
Out on the moors in November, the best time to shoot is midday or early afternoon. After this the sun will hide behind surrounding hills. About 4pm for night-time photography of Haworth's Main Street. Catch what is left of the blue sky for stunning evening shots, and shoot on rainy days – avoid weekends when it is busy.

ORDNANCE SURVEY MAP
Landranger sheet 104

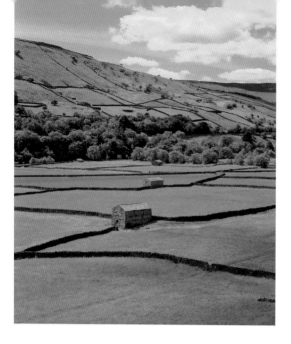

Left The composition of the three barns running diagnally across the valley floor is very effective. It was taken from the roadside just outside Gunnerside. *Pentax 67 with 135mm lens, 1/2sec at f/22, Velvia 50, polarizing filter, tripod*

FOR A CLASSIC YORKSHIRE DALES SCENE OF ROLLING HILLS DOTTED WITH SHEEP, FARM BUILDINGS AND DRY STONE WALLS, LOOK NO FURTHER THAN LOVELY SWALEDALE **DAVID TARN**

Swaledale and Arkengarthdale are the northern-most dales of the Yorkshire Dales National Park. If you were asked to supply a photograph of a typical Yorkshire Dales scene, chances are it would be of Swaledale. Field barns, dry stone walls and rolling green hills dotted with sheep – this is Swaledale.

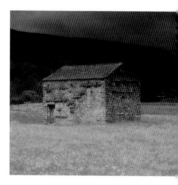

Staying nearby is easy, you have a choice of towns and villages starting with Richmond at the eastern end of the dale. Richmond is a large hilltop market town with a cobbled town square and an impressive castle overlooking the River Swale. Nearby Reeth is a large market town sometimes referred to as the capital of Swaledale. Further along the valley you pass through Grinton, Healaugh, Feetham, Low Row, Gunnerside, Muker, Thwaite and Keld. All can offer you accommodation of one sort or another, though Keld is bereft of a pub! Along the way a few minor

Right Within every scene there are always details. For this picture I wanted to concentrate on the flowers and just leave an impression of the barn and walls. A shallow depth of field also meant I could use a faster shutter speed and not worry about any movement that the breeze might cause.
Pentax 67 with 55mm lens, 1/60sec at f/4, Velvia 50, tripod, polarizer

Left This picture was taken further along the valley just outside the village of Muker. I don't use filters for this sort of effect very often, but this picture benefits from a soft-focus filter, and a sunset used to warm-up the image. The overall effect makes the photograph more impressionistic.
Mamiya RB67 with 180mm lens, 1/30sec at f/16, Velvia 50, soft-focus and sunset filters

roads take the higher routes through the dale, and these are worth exploring to find other good viewpoints. But the most rewarding way to explore much of the dale is on foot.

Because the Yorkshire Dales are under pressure from so many visitors, the Park Authority is keen to encourage the use of public transport. However, it is a sad fact that the hours photographers keep, and the need to move on whenever the light and conditions take you, necessitates the use of a car. Walk as much as you can once you are in the area you want to photograph. This way, you will always find more viewpoints and remember to stay on footpaths through the flower meadows. If we all stay on the footpaths we won't destroy what we have come to see and record. We will also avoid any unpleasant encounters with the farmers, whose efforts over the years are largely responsible for the way the dales now look. Having said that, much of the wonderful scenery in Swaledale can in fact be captured from the roadside. This wonderful scene (picture on opposite page, top) is taken from a layby just outside the

Left The dominant colour of the landscape during summer is green, so the wild flower meadow makes an interesting subject. A polarizing filter has saturated the colours and the deep blue sky contrasts well with the buttercups in the field. This view is from the road between Richmond and Gunnerside. *Pentax 67 with 55mm lens, 1/2sec at f/22, Velvia 50, polarizer, tripod*

village of Gunnerside. The row of three barns running diagonally across the valley floor never fails to attract photographers. With the composition being so well made already, I always feel you need to be extra careful over light and other elements in the scene to make the picture stand out. The wild flowers add a dash of welcome colour, and this was an especially bright day in June, with fresh, clear air.

FACTS ABOUT:

Swaledale

The Yorkshire Dales National Park covers approximately 1,600 square miles (4,144 square km) and features some of the most awe-inspiring upland scenery in the country. The River Swale runs from Keld to Boroughbridge and gives Swaledale its name. One of the most northerly dales, it is characterized by stone barns and flower-filled meadows, which in late spring form a stunning carpet of colour.

PLANNING

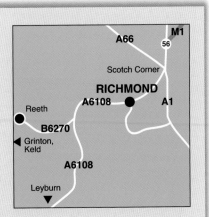

LOCATION
Swaledale lies in the north of the Yorkshire Dales National Park.

HOW TO GET THERE
To find Swaledale, leave the A1 at Scotch Corner and take the A6108 to Richmond. Continue on this road until the turn off for Reeth (B6270), which then continues to the far end of Swaledale at Keld.

WHERE TO STAY
Swaledale is full of good pubs, hotels, guest houses, youth hostels and self-catering cottages. I can recommend the food at the Kearton Country Hotel at Thwaite, tel: +44 (0) 1748 886277, www.keartoncountryhotel.co.uk It's named after the Kearton brothers, who were the first natural history film-makers in these parts and used imitation rocks and cattle to get closer to their subjects. For more information go to www.yorkshirevisitor.com

WHAT TO SHOOT
In Swaledale there are a number of good waterfalls to find, especially near the village of Keld. Wain Wath Force can be seen from the roadside just beyond the village of Keld. If you are prepared for a little walking, Kisdon Gorge and the waterfall are well worth a visit, especially after rain.

WHAT TO TAKE
Waterproof walking boots, rucksack (for your flask and sandwiches as well as camera gear), polarizing filter and a sturdy tripod.

BEST TIMES OF YEAR
The Yorkshire Dales can be good at any time of the year. In winter when it snows, the walls and barns make great patterns in an otherwise white landscape. Spring and autumn bring their own colours and both warrant a visit.

ORDNANCE SURVEY MAP
Landranger sheet 98

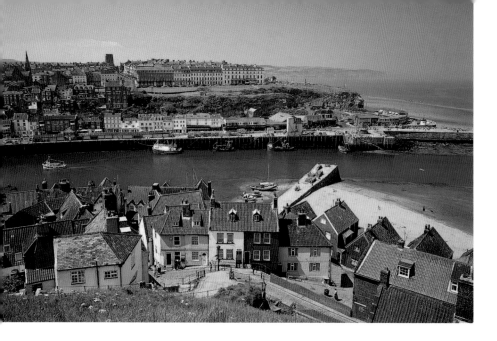

THIS BUSTLING PORT, SURROUNDED BY THE NORTH YORKSHIRE MOORS, IS PACKED WITH COLOURFUL AND SOMETIMES DRAMATIC SIGHTS TO ENTICE ALL PHOTOGRAPHERS **DAVID TARN**

There is enough in Whitby to keep a photographer busy for days. Surrounded on three sides by the North Yorkshire Moors and on the fourth by the North Sea, it sits in the centre of a large area of outstanding natural beauty.

At the top of the east cliff sit the ruins of a wonderful 7th-century abbey now owned by English Heritage. The abbey was once the setting for a meeting between Roman and Ionian Christians. Though both were Christian, they failed to agree on all matters of practice, most notably on the method of calculating the time for Easter. In 664 King Oswy ordered a meeting between the opposing parties, and this took place at Whitby Abbey. At this meeting St Hild showed wisdom and Christian charity and agreed to the Roman form for settling the date for Easter. This agreement stands to this day.

Above Whitby from St Mary's Church, looking back from the east cliff to the west and along the coast to Sandsend. The clean and clear nature of the light lifts this view. *Fuji GSW69III with fixed 65mm lens, 1/2sec at f/22, polarizer*

Whitby

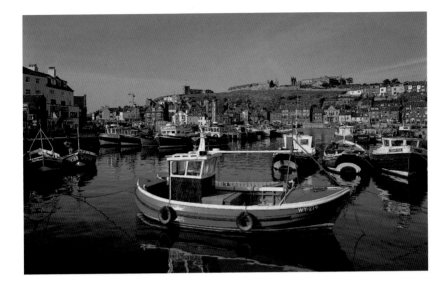

Above This picture was taken for a postcard and the wonderful conditions on that day have meant that I have never been able to improve on it. *Technical details not recorded*

Since the early days of photography when Frank Meadow Sutcliffe roamed the streets of Whitby with a large-format camera and glass plates, the best view of the abbey has always been across the little pond that sits in front of it. I used to be able to take pictures across this pond with the abbey perfectly reflected and the honey-coloured stone glowing in the early morning sun. Unfortunately, now you cannot gain access to this view until the site is open – by which time the best light has gone.

Whitby

Captain Cook is perhaps the most famous mariner to hale from Whitby but there was the Scoresby family too, who were primarily interested in whaling. They made careful observations of Arctic phenomena, invented nautical instruments and pushed further through the pack ice in 1806 than anyone had before. Whitby was also the home of famous photographer Frank Meadow Sutcliffe, who captured the scenes of Whitby 100 years ago, using a large-format camera and glass plates.

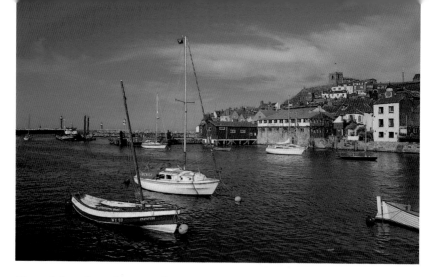

Above Leisure boats in Whitby harbour. The Fuji was a perfect camera for postcard photography, being light and portable and very easy to use. Sometimes I wonder why I traded it in...
Fuji GSW69III with fixed 65mm lens, 1/2sec at f/22, polarizer

The main body of Whitby is a fishing village and tourist haven. It has brightly coloured shops and brightly painted boats. It was these that brought me to Whitby to take pictures.

Though Whitby is not far from my home, and though I visit the town quite often, I have never been able to take the simple shot of the harbour, shown on previous page, in better conditions. Everything worked well – the tide was as high as it gets, the sun was shining from a nearly clear sky, the boats were arranged well, and there was no litter floating around in the harbour with the boats.

Whitby is a town to explore on foot, but that can involve some climbing. The famous 199 steps up the east cliff to the church are matched on the other side of the River Esk by steps that take you from a similar height down to the harbour.

In the morning the sun will be behind you on the east cliff looking back across the harbour to the west, and in the afternoon and evening this situation is reversed. High tide and sunrise suits harbours – low tide and sunrise suits beaches, and in the summer low tide and sunset at nearby Saltwick Bay or Saltburn are a great combination.

PLANNING

LOCATION
North Yorkshire coastline surrounded by the moors.

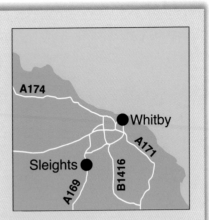

HOW TO GET THERE
Follow the A171, which goes through the moors, or the A174, which is the coastal route. Parking can be a problem at peak times.

WHERE TO STAY
This seaside town has plenty of accommodation. Contact the Whitby Tourist Information Centre, tel: +44 (0) 1723 383637 or go to www.yorkshirevisitor.com

WHAT TO SHOOT
There is no end to the list of things to photograph in Whitby. The fishing boats, the church, the abbey, the town, the harbour and the wide curving broad walks out into the sea. The beach to Sandsend and the rocky coastline to Saltwick Bay and Black Nab.

WHAT TO TAKE
Wideangle lens and a polarizing filter for pictures like these, but there are many other photographic opportunities as well.

BEST TIMES OF YEAR
Summer, due to the orientation of Whitby, on the north-east coast. At the height of summer the sun both rises and sets over the sea. All the colours are at their best when the grass on the hillsides around the abbey and town are a lush green.

ORDNANCE SURVEY MAP
Landranger sheet 94

THIS VIBRANT AND HISTORICAL CITY IS DOMINATED BY ITS
NORMAN CATHEDRAL, EXTENSIVE CASTLE AND IS RENOWNED
FOR ITS PRESTIGIOUS UNIVERSITY **DAVID TARN**

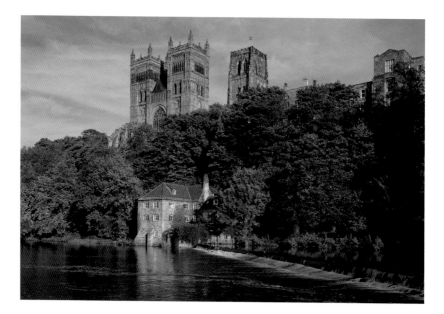

From the photographer's point of view the great
advantage of Durham Cathedral when compared
with others – especially York or Beverley – is the
clear, unobstructed view. It's right on the river, so no
one can park a tour bus or car in front of it. In
addition, the river is wide enough that, with a
moderate wideangle lens, you are far enough away
from the cathedral to avoid converging verticals. In
this respect it again has an advantage over York and
Beverley, both of which are close to other buildings.

Perhaps, then, this fortuitous setting is in part
responsible for the World Heritage Site status
afforded to Durham Cathedral, and for travel writer
Bill Bryson describing it as 'the best cathedral on
planet earth'. It is almost without doubt one of the
most beautiful buildings in England. The present

Above This image was taken from the landing stages behind the boathouse opposite Durham Cathedral. *Horseman 45HD with 90mm lens, 1/2sec at f/22, Velvia 50, polarizer and coral graduated filter*

cathedral was built in the late 11th and early 12th centuries and has stood now for more than 900 years. The cathedral was build to house the relics of St Cuthbert from Lindisfarne, and also holds the tomb of Bede, the first English historian and chronicler of Cuthbert's life. Durham Cathedral is the finest example of early Norman architecture in England.

Durham is a small city and easy to cover on foot. The cathedral and the castle are on a peninsula of land surrounded by the River Wear. The river is spanned by a number of bridges – the Millburngate Bridge affords another good view due south past the Framwelgate Bridge. There are footpaths along the riversides and the classic view of Durham Cathedral is from the far side of the river. Two spots make for a good picture. Stay to the north of a house and boathouse and include the weir, or walk around the back of that to the landing area for the boats, as I did for the main picture on page 150.

Below So close to the building, I used the perspective control of a large format camera. *Cambo 5x4in with 58mm Schneider lens, exposure details not recorded*

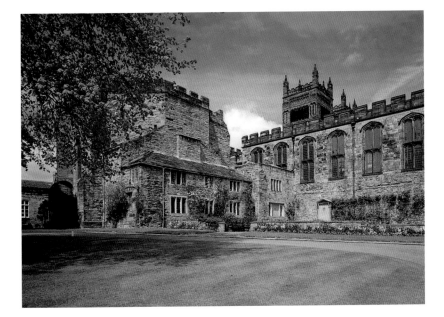

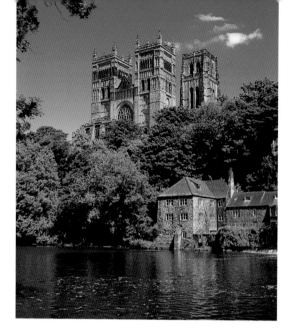

Above This is the classic view of the cathedral taken in early summer. *Pentax 67 with 55mm lens, 1/2sec at f/22, Velvia 50*

You can then continue walking along the river to Prebends Bridge, built in 1777, which offers another good view of the cathedral. Turner painted the cathedral from this spot, which is a pretty good recommendation. At the west end of the bridge a plaque features Sir Walter Scott's fond words about the city of Durham. Another good view of not just the cathedral and castle, but the city itself, comes from the railway station and Wharton Park.

FACTS ABOUT: Durham

Durham is a compact and vibrant city. There is an annual regatta, which has been held each June since 1834 – it's the second oldest in the country, and older than Henley. The second Saturday in July has seen the Durham miners' gala for more than a century. Despite the closure of all the mines in Durham, ex-miners and their families still gather. Bands from closed collieries still parade behind colourful banners. There is pride in the history of a region built on mining and heavy industry.

PLANNING

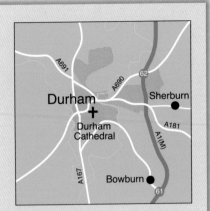

LOCATION
Durham is in north-east England, just off the A1(M).

HOW TO GET THERE
From the A1(M) just follow the signs. Junction 62 and the A690 take you into the city centre. There is usually plenty of parking along the riverside.

WHERE TO STAY
There are plenty of accommodation options for all budgets. For listings, contact the Durham Tourist Information Centre, tel: +44 (0) 1913 843720, or go to www.durham.gov.uk

WHAT TO SHOOT
The cathedral and castle are the obvious subjects in Durham, though a number of the bridges might also make interesting photographs, as well as the river and boats. The cathedral and castle are floodlit at night, as are some of the bridges. Try dusk for a more unusual shot of the city.

WHAT TO TAKE
A wideangle lens equal to 35mm on a 35mm camera, and a tripod with spirit level.

BEST TIMES OF YEAR
My favourite for Durham is the autumn. During the summer the trees are too overpoweringly green and in winter they are too bare and drab. Spring is good as well.

ORDNANCE SURVEY MAP
Landranger sheet 88

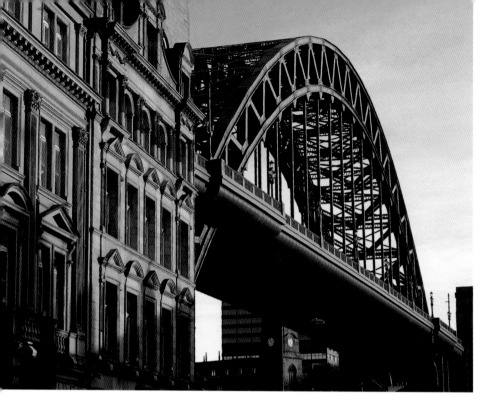

A CITY BUZZING WITH ENERGY AND CREATIVITY, NEWCASTLE HAS BECOME THE CULTURAL CENTRE OF THE NORTH-EAST, WITH GREAT CONTEMPORARY ARCHITECTURE TO SHOOT **CRAIG ROBERTS**

Tyne Bridges, Newcastle

Above By using a 180mm lens from a distance, I compressed the perspective between the bridge and the sunlit building.
Mamiya RZ with 180mm lens, 1/30sec at f/22, Velvia 50, 81B filter

For much of my recent photography, I have been focusing on England's wonderful cities, mainly because their aesthetic potential has increased with the development and rejuvenation that has taken place in some of the larger ones. I have visited Portsmouth, Glasgow and Birmingham. My latest, however, was Newcastle and in particular its impressive waterfront.

There are six main bridges on the Tyne, the newest being the Millennium Bridge, which was built as part of the redevelopment of the area. Also built around the same time is the Sage Gateshead Building, which is an unusual, curved shaped structure that also has

potential for some great images. The most striking bridge however, is the Tyne Bridge which resembles the famous Sydney Harbour Bridge in Australia.

I wanted to capture the bridges on the Tyne lit up after dark and had seen some examples of how impressive they look in various magazines. I also wanted to make use of the great light that I was having on that sunny afternoon and so set about exploring the Tyne Bridge for unique compositions.

As I walked around, viewing it from all angles, I found a street almost directly under the north-bank supports, where the sun was casting its warm light on the bridge as well as on a lovely old building in the street. There were road works right at the bottom of the road at the entrance to the building and at first I thought these were going to totally ruin the shot. Therefore, my first solution was to fit my 75mm shift

Below This was one of the last shots I took before the sun went down. After shooting the bridge in its surroundings, I went for a more abstract view which was easy to do due to the simple design of the bridge. *Mamiya RZ with 50mm lens, 1/8sec at f/32, Velvia 50*

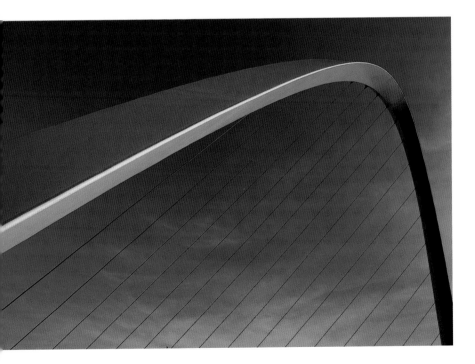

lens on the camera as I thought this would keep the verticals on the building straight, as well as eliminate the road works. However, I just couldn't get the composition I wanted, so instead I switched to a 180mm telephoto and walked further up the incline of the road. I found I could now get the perfect composition, with the telephoto also proving useful to compress the perspective between the bridge and the building for greater effect. Because of the higher viewpoint, I could also crop out the unsightly road works and I didn't have to tilt the camera up too much, so the verticals were kept straight as well.

To further increase the warmth of the sunlight, I put an 81B filter over the lens. It was then a case of shooting as many frames as possible in both horizontal and vertical formats before the shadow from the buildings opposite crept into view.

I spent the rest of the afternoon shooting the other bridges with the last few rays of sunshine before turning round and shooting them in silhouette against the setting sun. After a quick bite to eat I was ready to do the night shots.

Tyne Bridges

In 1996 Gateshead Council launched a competition to design a new bridge on the Tyne. The result is the new Millennium Bridge. It's designed to open like an eye and takes four and a half minutes to do so. The arch is lit with a series of high-powered lights which change colour to add to the design. In the week it is lit with a crystal white light and at weekends it changes to a spectrum of colours. The older Tyne Bridge was opened by King George V, accompanied by Queen Mary, on October 10th, 1928. The main span is 531ft (162m) and has a clear headway over the river of 84ft (26m). It cost £700,000 to build but recently it has just finished a makeover costing £1.8 million.

PLANNING

LOCATION
Newcastle is located on the north-east coast, flanked by the Pennines and Northumberland National Park.

HOW TO GET THERE
Being a large city it's superbly served by air, rail and road. The Metro system takes you into Newcastle from the airport and it's a 15 minute walk from Newcastle Central train station.
By car, the city is a direct route off the A1(M), running up the east side of the country.

WHERE TO STAY
You will find a great variety of accommodation on offer here. For more details contact the Newcastle Tourist Information Centre, tel: +44 (0) 1912 778000, or go to www.visitnewcastle.co.uk

WHAT TO SHOOT
The Gateshead Quays including the Millennium Bridge, Sage Gateshead and the old Baltic flourmill, which is now a centre for contemporary art.

WHAT TO TAKE
Comfortable shoes. Shooting by the riverside can feel cooler, so take warm clothing. A tripod is useful.

BEST TIMES OF DAY
Afternoon and evening is a great time to visit, but there's obviously lots to shoot in the morning too.

BEST TIMES OF YEAR
You can shoot the city and its bridges throughout the year, but there are events like the Tall Ships Race that may be worth timing your visit for.

ORDNANCE SURVEY MAP
Landranger sheet 88

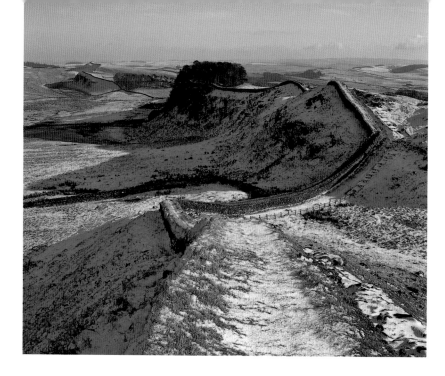

A SPECTACULAR FEAT OF THE ROMAN EMPIRE, HADRIAN'S WALL
STILL STANDS OVER 2,000 YEARS AFTER IT WAS BUILT AND IS
A TANGIBLE LINK TO OUR ANCIENT PAST **SIMON FRASER**

Above The much
photographed, classic
view of Hadrian's Wall
and Housesteads
Crags in winter.
*Bronica SQ-A with 40mm
lens, 1/30sec at f/16,
Velvia 50, tripod*

Hadrian's Wall stretches across the far north of
England, from the Solway Firth to the North Sea,
and is undoubtedly the most important Roman site in
the United Kingdom. It became a World Heritage Site
in 1987, ranking alongside such treasures as the Taj
Mahal and the Galapagos Islands, and warranting
special recognition and protection.

In many ways, winter is an excellent time in which
to photograph the wall. The low angle of the winter
sun shows up many details, particularly the ditch and
'vallum' north and south of the wall. On a sunny day
with a hard frost, or fresh snow, it looks magnificent
as it marches across the rolling hills and crags under
endless skies. There are fewer visitors in winter, and
the area regains its wild, frontier atmosphere.

The most spectacular section is the 12 miles (19.3km) between Greenhead and Sewingshields where the wall follows the crest of the Whin Sill, a ridge of very hard quartz-dolerite. Much of the rest of the wall was levelled and used as road foundations by General Wade during the 18th century to deploy troops against the Jacobites. The rugged Whin Sill section was left untouched, and ironically it is General Wade's road, the B6318, still referred to as the Military Road, which gives access to the most spectacular sections of the wall.

As with any landscape subject where the focus of interest is the view rather than intricate details, successful images depend on weather conditions and lighting, as well as choosing the best location. Hadrian's Wall seen from Cuddy's Crags near Housesteads Fort is the classic view, capturing the

Below View north from Hadrian's Wall over sparsely populated grazing land towards Kielder Forest.
Nikon F90x with 70–300mm lens, 1/15sec at f/11, Velvia 50, tripod

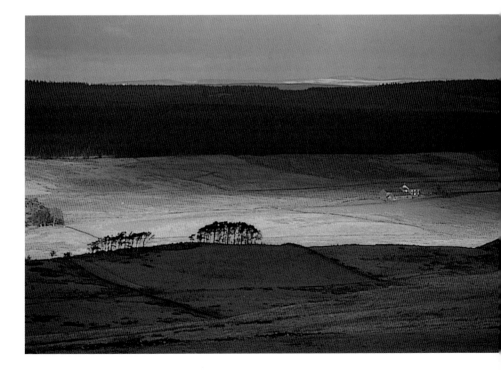

essence of the wall as it hugs the craggy summits of the Whin Sill. Even though the Scottish border is some distance away, the wall still feels like a boundary between the more populated lands to the south and the vast open spaces to the north.

Further west lies Crag Lough. A conspicuous landmark here is 'Sycamore Gap', where a lone tree stands in a saddle on the Whin Sill. As with many locations on the wall, Sycamore Gap looks at its best either under snow in a hard winter, or alternatively with the fresh, vibrant greens of early summer. Much of the winter is snow-free, with the colours of the land more muted and dull. These wide-open and exposed spaces can sometimes seem bleak and lonely, presenting a considerable challenge to the photographer. But experiencing the land in all its moods, seeing the changes in light and weather, are all part of the enjoyment of landscape photography.

There is much to explore along Hadrian's Wall, but Walltown Crags, Milecastle 42, Steel Rigg, Crag Lough and Housesteads Fort offer the most inspiration. It has an atmosphere of history and space, and I still feel a sense of awe whenever I see the ancient stones, hewn by Roman soldiers nearly two millennia ago, almost untouched by the passage of time.

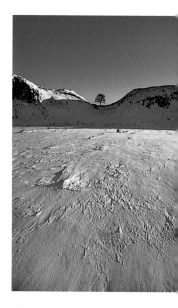

Above Sycamore Gap from the north, with deep snow.
Nikon F90x with 20mm lens, 1/125sec at f/8, Velvia 50

Hadrian's Wall

The wall was built on the orders of Emperor Hadrian in AD122. It took about six years to complete the 73 miles (117.5km). The wall's purpose was to mark the northern boundary of the Roman Empire and it stood at about 16ft (5m) high. By the 5th century, the empire was in terminal decline, the frontier was abandoned and many of the stones of the wall were taken away for use in field walls, houses and churches, which are sometimes still visible today.

PLANNING

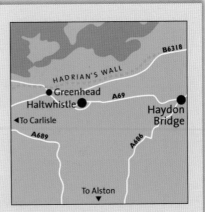

LOCATION
The best-preserved section of wall runs parallel to the B6318, near Haltwhistle, Northumberland.

HOW TO GET THERE
By car: from the A69, turn off and follow the B6318. A bus service goes to the main Roman sites in the summer, with a limited service in winter. For more information go to www.hadrians-wall.org

WHERE TO STAY
There are plenty of hotels, B&Bs, cottages, youth hostels, caravan and camping sites in and around nearby towns and villages.
For more information go to www.visitnortheastengland.com or www.hadrians-wall.org

WHAT TO SHOOT
The wall, its various milecastles and forts. Views of the bleak, but beautiful, surrounding landscape.

WHAT TO TAKE
Lenses from wideangle to telephoto, tripod, graduated neutral-density and polarizing filters. Weatherproof clothing is essential in winter. Carry food and drink with you if walking long sections of the wall.

BEST TIMES OF YEAR
Many locations along the wall look dramatic under snow in winter, but equally good with the fresh greens of spring.

ORDNANCE SURVEY MAP
Landranger sheet 87

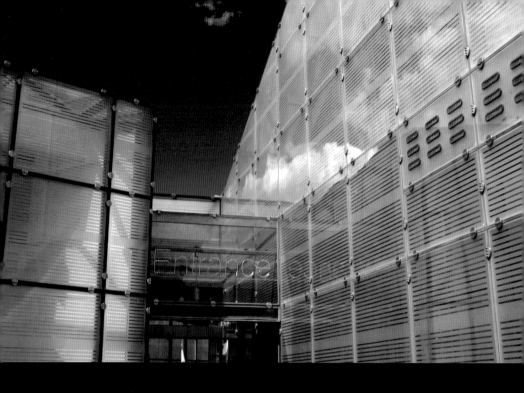

PART SEVEN THE NORTH-WEST

MANCHESTER'S INDUSTRIAL IMAGE IS NOW A THING OF THE PAST.
WITH ITS VIBRANT ATMOSPHERE AND AWESOME ARCHITECTURE IT
IS A STIMULATING AND CULTURAL DESTINATION **STEVE MORGAN**

The Lowry stands at the heart of the redeveloped Salford Quays in Greater Manchester. Named after the artist LS Lowry, known for his images of working-class life during the early years of the last century, its multi-hued, glittering lights reflected in the angled surfaces of glass and metal are a far cry from smoking chimneys and dark satanic mills. The Lowry is a dramatic looking complex of buildings, which bears the name of one of Salfords most famous sons and is an internationally renowned arts venue.

Overlooking the old docks, these buildings present both an opportunity and a challenge to the photographer wishing to find new angles and viewpoints. Most of the images here have been taken at night, but equally, with the many angles, surfaces and materials on display, shooting on a bright day using harsh shadow and a polarizing filter could enhance the graphic quality of the construction.

Above Shot on a bright sunny day Urbis is a pleasant challenge to photograph. No tripod to use here, which can free you up to move around and pick the right spot to shoot from more easily. *Eos D30 with 24mm lens, 1/50sec at f/11, ISO 100*

I wanted to show the dramatic curves and arcs of the front of the Lowry, but with the more angular and square-looking Digital World Centre buildings in behind. By shooting at night the effect is enhanced when both buildings have dramatic lighting.

Around Salford Quays there are a number of opportunities for both day and night photography. For the wider shots, dusk can present interesting possibilities balancing the declining ambient light and its associated setting sun colours. Or timed with the switching on of the electric lights that adorn buildings and street furniture.

Left A wide shot of the front entrance to the Lowry. While technically converging uprights are not really desirable in architectural photography they are difficult and expensive to eliminate in everyday situations without resorting to shift lenses or monorail cameras. On the upside, they can be used to create drama and graphic perspectives in a photograph.
Eos 20D with 20mm lens, 2.5secs at f/9, ISO 100

Manchester and Salford

Manchester and Salford have seen some huge changes – the rise of Cottonopolis, as it became known, saw it develop from a small village in the 1750s to become the world's largest cotton milling area by the end of the 19th century. However, lack of investment and declining markets led to economic downturn. Ironically, it took the IRA's bomb of 1996, which destroyed much of the city centre, to kickstart regeneration, bringing people back to enjoy the cultural and hedonistic delights.

Below The large blocks of the Digital World Centre looked colourful and the focal length again was important to fill frame but also to use a long focal length from a distance to flatten the perspective.
Eos 20D with 103mm lens, 2.5secs at f/7.1, ISO 100

Just to east of the city of Salford, across the River Irwell, lies its illustrious neighbour, Manchester, once famous as the centre of the cotton industry, which bequeathed to the city a mixed bag of grand Victorian architecture such as Manchester Town Hall alongside the ranks and rows of terraced housing.

Manchester centre has become a lively and vibrant place since redevelopment of its shopping area following the IRA bomb in 1996. The Urbis Museum near Victoria station is a popular subject. Also the China Town area, especially at Chinese New Year. Each year, there is a large Gay Pride march offering interesting and colourful subject matter.

PLANNING

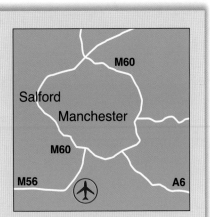

LOCATION
Manchester with the city of Salford are in the north-west of England.

HOW TO GET THERE
Greater Manchester is a major conurbation so transport links are plentiful. By car: the M6 will lead you there from the south and the north and the M62 from the west and east. By train: Manchester Piccadilly – trains every half-hour during the day on the new upgraded main West coast line to London and all points north. Manchester Airport is the UK's third largest airport and is situated 10 miles (16km) south of the Manchester city centre.

WHERE TO STAY
There is such a wide choice of accommodation that it is best to contact the Tourist Information Centre, tel: +44 (0) 1612 343157 or go to www.visitmanchester.com

WHAT TO SHOOT
Salford Quays: the Lowry during night and day, Imperial War Museum and Millennium Bridge. Urbis near Victoria station. Interesting industrial heritage remains in the network of canals through the city centre. The Castlefield area has iron bridges over the canals which make strong graphic subjects. The Chinese Arch in Chinatown, near Portland Street/Charlotte Street. Many fine Victorian buildings, especially the Town Hall in Albert Square.

WHAT TO TAKE
A tripod for the night shots, although a cable release is not strictly necessary as you can use the self-timer. A polarizer for the day shots to darken the sky and take out unwanted reflections.

BEST TIMES OF YEAR
Any time of year, but, north-west England gets plenty of rain.

ORDNANCE SURVEY MAP
Landranger sheet 102

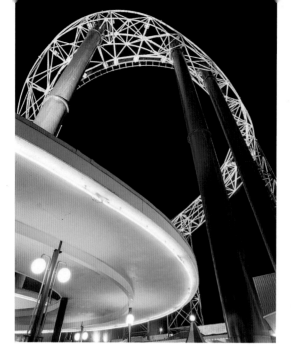

Left Photographing a part of a large subject can often produce a better picture than trying to capture the whole view. The Big One rollercoaster loops back and forth above the Blackpool Pleasure Beach and this is just one of many viewpoints that I found both graphic and dramatic.
Canon EOS 50E with 20–35mm lens, Velvia 50, 10secs at f/16, tripod

BLACKPOOL'S FAIRGROUND ATTRACTIONS ARE PERFECT FOR ADRENALIN JUNKIES, BUT THE MORE SEDATE VISITOR MAY PREFER TO JUST TAKE IN THE FABULOUS ILLUMINATONS **STEVE DAY**

Blackpool at night makes for an exciting and challenging subject for any photographer. Of course, the illuminations are one of the resort's main attractions, and once the thousands of lights are switched on in early autumn, there is a wealth of colourful subjects to shoot. However, for me, the best photographic subject is the Pepsi-Max Big One rollercoaster, so I recommend a visit during the illuminations when you can combine the two subjects.

The Big One is a superb rollercoaster that absolutely terrified me when I rode it. I'm no coward, and certainly not scared of heights or speed, but the rictus grin on my face at the end spoke volumes. This rollercoaster offers so many possibilities when it comes to pictures. It dominates the promenade, and there's plenty of scope for shots showing the

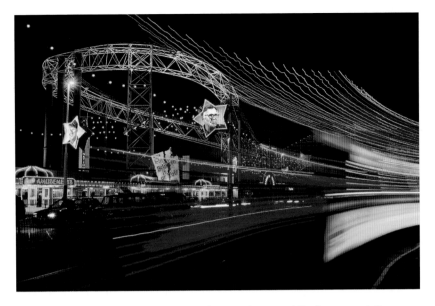

Above I'd tried photographing the light-decorated trams while they were stationary but they lacked something. I felt it was better to reduce the bright lights to colourful streaks. For this shot I set up the camera with a black cloth draped over the lens. I used the bulb setting and a locking cable release so that the shutter was permanently open. When the tram approached I took the cloth off the lens and as soon as the tram neared the left-hand side of the screen I tripped the closing of the shutter. I did take a similar shot that included a burst of flash on second-curtain sync, but felt that this spoilt the picture – I like light trails to exist in their own right.
Canon EOS 50E with 20–35mm lens, exposure details not recorded, Velvia 50, tripod

Right Always make use of water when it's around. The funfair has a small lake in the middle and this general view is enhanced by reflections.
Canon EOS 50E with 28–135mm lens, exposure details not recorded, Velvia 50, tripod

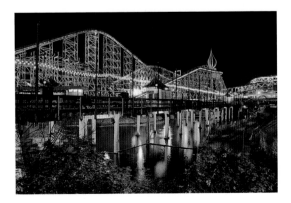

Blackpool

The Pepsi Max Big One rollercoaster is 235ft (71.6m) high. It dives at a 65-degree angle on the first drop. It reaches 85 miles per hour (137kp/h) on that drop and you appear to be diving straight onto Blackpool Beach. The Blackpool illuminations are a major attraction every autumn. Stretching for 6 miles (9.6km), the lights draw in crowds of more than 8 million visitors.

Expert Advice

Multiple lights are actually difficult to shoot, in that point-sources fool a camera's meter. I've found it a reasonable rule of thumb that centreweighted metering gives about a stop underexposure in these situations. Given that a half to one stop needs to be added to any night picture shot on film, it's no use using exposure compensation – most cameras only have a two-stop adjustment. Instead, I set a film speed of ISO 12 (I was using Velvia 50) and then I bracketed at half-stops.

structure towering over the surrounding buildings. During the day it makes for an impressive subject, but at night it comes into its own as the lighting switches on, and the shape is emphasized against the dark sky. Despite its immensity, I got the greatest reward from photographing a small part of it as a graphic shape.

The main shot, on page 168 simply shows a small part of the track, in the middle of Blackpool's Pleasure Beach, where the rails twist and turn above the funfair. I felt a dramatic viewpoint was needed to complement the subject so I lay down on the tarmac. Converging verticals didn't worry me at all for it was the shape that mattered. The curve of the foreground roof balanced the curve of the ride, and contrasted with the straight lines of the supporting pillars of the track, which provided a striking picture.

There is a wealth of subjects along the promenade. Blackpool Tower makes a good shot, but beware that the lights go on and off, and you have to time your shot. The big wheel on the pier and the roundabouts in the funfairs also make good subjects, best shot on long exposures. Don't forget the trams. Many of them are decorated to look like steam trains or rockets. I got the best results by shooting a lengthy exposure as they passed, reducing them to streaks of coloured lights.

PLANNING

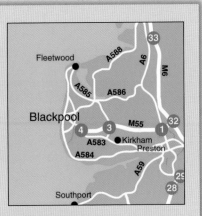

LOCATION
Blackpool is on the west coast of Lancashire in north-west England.

HOW TO GET THERE
The M55 leads to the resort. If you're going when the illuminations are on then follow the signs for parking – don't be tempted to drive along the promenade looking for a parking place – you'll end up in bumper-to-bumper traffic, moving at a crawl, and won't find anywhere to park.

WHERE TO STAY
Blackpool has a vast range of accommodation options. For full listings contact the Tourist Information Centre, tel: +44 (0) 1253 478222 or go to www.visitblackpool.com

WHAT TO SHOOT
The Big One and other fairground rides, the illuminations, Blackpool Tower and trams.

WHAT TO TAKE
A tripod is a must though you don't have to use a cable release – the self-timer will do. Use slow film to make the most of the colours, and take a wideangle if you want to get dramatic shots of The Big One.

BEST TIMES OF YEAR
The Big One makes a good subject throughout the year, but the illuminations are only lit from September to early November. For dates and more details, go to www.visitblackpool.com

ORDNANCE SURVEY MAP
Landranger sheet 102

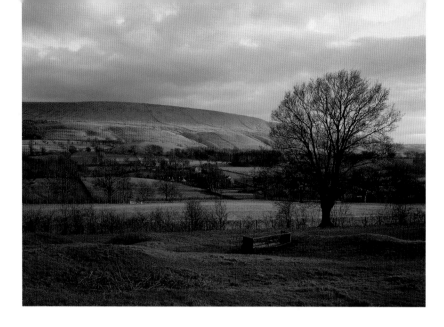

BENEATH THE IMPOSING PENDLE HILL LIES DOWNHAM IN THE RIBBLE VALLEY, ONE OF LANCASHIRE'S PRETTIEST VILLAGES. A GREAT PLACE TO PHOTOGRAPH RURAL SCENES **ANDY LATHAM**

February can be a tricky month if the snow has not fallen or the mornings aren't crisp. It can be an inbetween time of year – the best of winter is nearly over and the joys of spring not yet upon us. One February I lacked motivation to get out and take photographs. The best way to break out of this state is to set myself a project, and so it was that I extended my photographic area to Lancashire's beautiful Ribble Valley. The jewel of the Ribble is the mighty, magical Pendle Hill and the jewel of Pendle is the pretty village of Downham – a perfect place to start.

I first visited on an afternoon of mixed weather and uninspiring light and decided to go for a stroll up Pendle Hill where I was rewarded for my efforts. As I began the descent to Downham, the sun broke through the cloud and the whole of the Ribble Valley was bathed in gorgeous light. The views were fantastic, from the rural delights of the valley below

Above Downham nestles beneath the northern slopes of Pendle Hill, so I decided to shoot it in its wider environment. The picture depends entirely for its effect upon the soft, warm evening light that highlights the village buildings and the hillside beyond. *Mamiya 7II with 65mm lens, 1/2sec at f/11, Velvia 50, 81B warm-up filter, tripod*

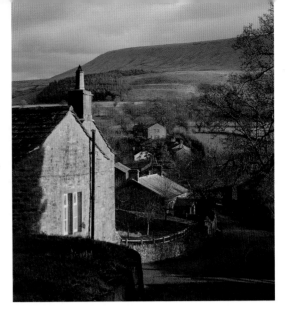

Right This is the classic view of the village looking down the main street with Pendle beyond. I used the 150mm lens to tighten the composition and compress the perspective slightly. The fact that this spot is in the middle of the road adds an element of urgency not normally associated with landscapes!
Mamiya 7II with 150mm lens, 1/15sec at f/11, Velvia 50, tripod

to the mighty hills of Ingleborough and Pen-y-ghent on the horizon. The stunning scene helped to remind me that the essence of good landscape photography is the quality of light, regardless of the time of year.

Suitably inspired I returned to Downham the following day on a breezy afternoon of drifting light. Being midweek in February, the village was quiet and I was able to take several shots without too much interference from cars or fellow visitors.

The other classic view of the village is from the top end, looking down the main street with Pendle Hill in the background. This proved trickier to obtain as I had to set up the tripod in the middle of the road – a task that would be impossible during the summer.

The main picture, on the facing page, was taken towards the end of the day when I wanted a bigger view of the village and Pendle Hill. The map revealed a path to Downham Green that ran along slightly elevated ground and this proved to be ideal. It provided a good view across the fields to the village, a solitary tree and Pendle Hill looking splendid in the warm, raking light. Initially, I found the feeding

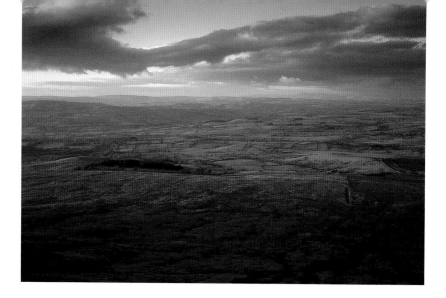

Above From Pendle Hill there are great views of the Ribble Valley and Yorkshire Dales beyond. Downham can be seen at the bottom left corner. *Mamiya 7II with 65mm lens, exposure details not recorded, Velvia 50, tripod*

trough distracting, but couldn't find a composition that excluded it. In the end it stayed and, on reflection, I think it adds to the rural feel of the scene.

Taking the photograph was fairly straightforward. The elevated viewpoint meant that I didn't need a small aperture as the foreground interest was several metres away and I used a warm-up filter.

As the light faded I felt very pleased with these couple of days of photography – I had obtained some decent photos and reminded myself of the quality of light, peace and quiet available in February.

FACTS ABOUT:

Downham

Downham is one of Lancashire's prettiest villages, its charms accentuated by the looming presence of Pendle Hill. St Leonard's church contains parts of a 15th-century church and legends claim it contains three bells from Whalley Abbey. Other buildings of note are the Tudor Old Well Hall, a former manor house and numerous handloom weavers' cottages. Nearby Worsaw End was the location for the Hayley Mills film, *Whistle Down The Wind*.

PLANNING

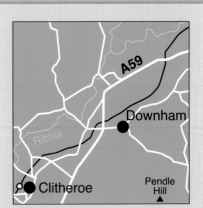

LOCATION
About 2.5 miles (4km) north-east of Clitheroe in Lancashire.

HOW TO GET THERE
From the south, bypass Clitheroe on the A59 then turn off on to the A671 for Chatburn, from Chatburn bear right for Downham.

WHERE TO STAY
There is a B&B at Downham Post Office, tel: +44 (0) 1200 441242, or plenty in nearby Clitheroe.
For listings, contact the Clitheroe Tourist Information Centre, tel: +44 (0) 1200 425566, or go to www.visitenglandsnorthwest.com

WHAT TO SHOOT
St Leonard's church, the village buildings, Downham Beck and bridge, Pendle Hill.

WHAT TO TAKE
A variety of lenses, polarizing, warm-up filters and a tripod. Also, plenty of patience at the busier times of year.

BEST TIMES OF YEAR
Spring is great for the daffodils by the village stocks. Late afternoon is usually best for the quality of light on the hill.

ORDNANCE SURVEY MAP
Landranger sheet 103

JUST SOUTH OF KESWICK IN THE STUNNING CUMBRIAN LAKE DISTRICT IS 300-YEAR-OLD ASHNESS BRIDGE, A POPULAR AND BEAUTIFUL SETTING FOR PHOTOGRAPHY **LEE FROST**

There are certain scenes up and down the country that have come to be regarded as classic examples of the English landscape at its very best. Ashness Bridge is one of them. It may be cliched and over-photographed, but there's a very good reason for this. It is one of the most compositionally perfect and naturally beautiful scenes you're likely to find in the whole of the Lake District. From the tumbling Ashness Gill and 300-year-old stone bridge, to the furtive glimpse of distant Derwentwater and Bassenthwaite and the magnificent fells of the Skiddaw range, it's got the lot.

Right An overcast November day meant waiting for a break in the clouds for a chance to shoot this classically beautiful scene. *Pentax 67 with 55mm lens, 1/2sec at f/22, Velvia 50, 81C warm-up filter, 2-stop neutral-density graduated filter, tripod*

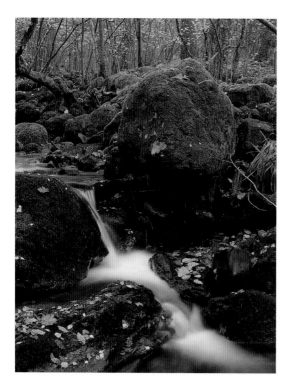

Left Barrow Beck flowing between mossy boulders in woodland near the Ashness Bridge car park. Grey, drizzly weather ruled out wider views, but such conditions bring soft, shadowless light that's ideal for recording the rich colours of autumnal woodland. *Pentax 67 with 55mm lens, 2secs at f/16, Velvia 50, polarizer, 81B warm-up filter, tripod*

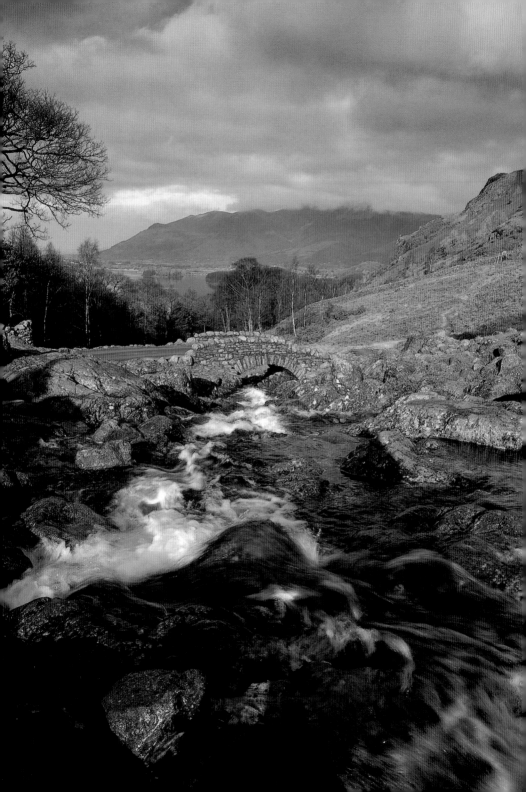

The main image shown on the previous page was taken during early November, on one of those frustrating autumnal days where the sky is laden with dark clouds, with frequent bursts of heavy rain. However, experience has taught me that such weather conditions are worth braving because if a break does appear and light falls where you want it to – the effect is always magnificent. Just make sure you're ready at that moment to capture it.

Arriving late in the morning, I found a convenient rock in the middle of the stream that was big enough for me and my tripod, then composed the beautiful scene through a 55mm wideangle lens on my trusty Pentax 67 camera.

Front-to-back sharpness was achieved by stopping down to f/22 then using the depth-of-field scale on the lens barrel to determine the point of focus. An 81C warm-up filter enhanced the rich autumnal colours and a 2-stop neutral-density graduated filter exaggerated the stormy sky. This was angled to follow the bracken-clad ridge and line of trees running high on the right to low on the left.

All I had to do then was wait patiently. I could see from the drifting clouds that a break was surely imminent, and after 30–40 minutes my prayers were answered – a brief burst of sunlight hit the foreground of the scene. It only lasted 30 seconds, but this was long enough for me to take a spot reading from the sunlit bridge to determine correct exposure – 1/2sec at f/22 – and fire off a few frames before cloud obscured the sun again.

FACTS ABOUT:

Ashness Bridge

300-year-old Ashness Bridge was originally built for packhorses travelling between Keswick and Watendlath, but today the traffic is mainly four-wheeled rather than four-legged. There are few restrictions in this area. Some of the woodland near the car park is fenced off, though I have never been challenged for venturing beyond it. Ashness Woods a little further up the road are managed by the National Trust. There are numerous parking areas provided, so make sure you use them rather than pulling up by the roadside and damaging the verges, which are often boggy due to surface water coming off the hills. Take care when shooting from Surprise View – it's a long way down.

PLANNING

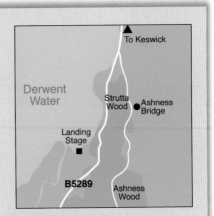

LOCATION
Ashness Bridge is located 3 miles (4.8km) south of Keswick in the Lake District, Cumbria.

HOW TO GET THERE
By car: head south from Keswick on the B5289, signposted Borrowdale. Take a left turn onto a minor road signed for Watendlath and Ashness Bridge. Follow this road and cross the bridge, there is a car park on the right. By bus: buses leave from Keswick bus station, get off at Ashness Gate then walk up the minor road to Ashness Bridge.

WHERE TO STAY
For full listings contact the Keswick Tourist Information Centre, tel: +44 (0) 1768 772645 or visit www.golakes.co.uk

WHAT TO SHOOT
The view to Ashness Bridge and beyond is the obvious highlight. A little way up the road is Surprise View, with superb panoramic views across Derwentwater. Grange village, near the Ashness Bridge turnoff, is highly photogenic, plus the B5289 gives great views.

WHAT TO TAKE
Stout boots are advised for safe rock-hopping, plus waterproofs. A 28–70mm zoom will cover your needs for views and details, plus polarizer, warm-up and neutral-density graduated filters, slow-speed film and a tripod.

BEST TIMES OF YEAR
Ashness Bridge is great all year, with every season adding its own magic. Strutta Wood and Ashness Woods in autumn for woodland views, while Watendlath looks magnificent on a clear afternoon with its cottages and bracken-covered hills reflecting in the beck. Winter to photograph Derwent from the shore using fences and jetties as foreground interest.

ORDNANCE SURVEY MAP
Landranger sheet 90

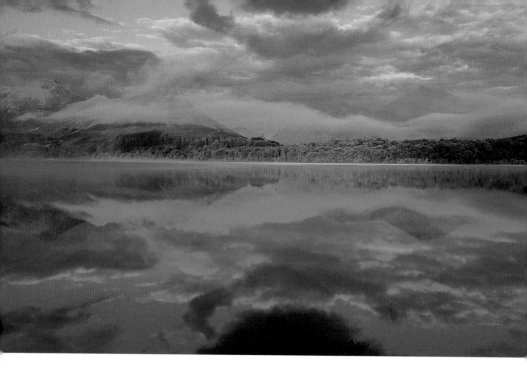

DERWENTWATER IS THE PERFECT PLACE TO CAPTURE A CLASSIC
LAKE DISTRICT SUNRISE, WITH ITS MIRROR-CALM REFLECTIONS
AND MIST-SHROUDED WATER **DAVE PORTER**

There can be few more photographed areas in the British Isles than Derwentwater near Keswick in the Lake District. From every fell, footpath and shoreline the rugged, mountainous landscape that surrounds the water is breathtaking. The lake is 3 miles (4.8km) in length and is accessible from footpaths that run all the way around the perimeter. Formed from a glacial channel and volcanic activity millions of years ago, the valley in which Derwentwater lies is now lined with lush trees, thick woods, swathes of bracken, sheep-filled pastures and gentle becks that run down from the crags and fells overlooking the clear crisp water. Keswick itself is a haven for walkers, tourists, photographers and people who just like the great outdoors.

Above A calm morning made for misty conditions and perfect reflections for capturing Cat Bells fell from the shoreline at Friar's Crag. *Minolta 800si with 28–80mm lens, 2secs at f/16, Velvia 50, polarizer, 81A warm-up filter, tripod*

Derwentwater

We landscape photographers are well-versed in the old clichés about getting up early to capture those golden morning rays and staying out late to record the colour-soaked sunsets. This is how my alarm came to be set to go off at 5.30am on a November morning in Keswick. There was just enough time to get to the shoreline at the north end of Derwentwater, set up the tripod and camera and capture the light as the sun rose.

Having checked the weather forecast the previous night, I knew the high pressure system sitting over the Lake District would give calm and misty conditions. On peering out of my window, I was greeted with an unexpected delight, the moon skimming the tops of the mountains and reflecting perfectly in the lake's mist-shrouded, calm waters. A wonderfully atmospheric scene.

Below At 6am, the moon was skimming the mist-shrouded lake creating perfect reflections. A launch in the foreground completed the atmospheric image. *Minolta 800si with 28–80mm lens, 8secs at f/8, Velvia 50, tripod*

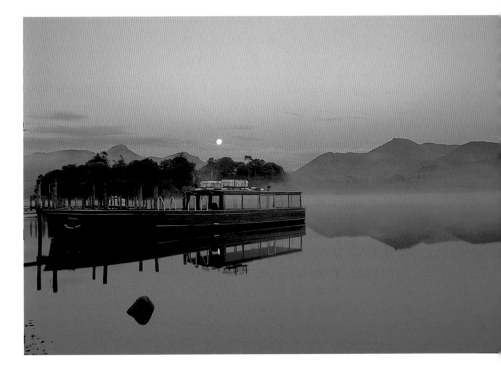

Derwentwater

Derwentwater lies in the north of the Lake District. At 3 miles (4.8km) long, it has several islands that break up the calm surface. There are marked footpaths all around the lake, where you can take pictures from the shoreline. Walks up to Cat Bells fell on the west side and Surprise View on the east offer elevated views of the lake and surrounding fells. Borrowdale village to the south has a lovely old stone bridge over the river and views down the length of the lake.

Expert Advice

You have to be quite quick to capture these early morning misty conditions; as the sun rises, so does the temperature and it's not long before the mist is burnt away.

The image on page 180, reflecting Cat Bells fell, was taken from a shoreline viewpoint on the eastern side of the lake at Friar's Crag at about 7.30am. From previous experience I knew that the sun would rise from behind Waller Crag, which hangs above Friar's Crag, and would bathe Cat Bells fell in glorious warm sunshine. I selected a position right by the lake's edge and framed the image in the centre to give a perfect reflection. Setting the tripod up on the shore, and being careful not to ripple the water, I selected an 81A warm-up filter to boost the morning light. With the slow speed of Velvia the exposure read two seconds at f/16. I bracketed a stop either side, but was spot on with the initial reading.

The image on page 181 was taken at about 6am. On arriving at the lake, I knew that the rowing boats and pleasure launches would be by the shoreline – perfect as foreground subjects. With the added bonus of a low moon, I wasted no time in framing a launch. Unpacking my 35mm outfit I started by composing the scene. Once I had seen the shot I wanted, I set up the tripod and took some images using the moon as a point of interest, reflected in the gently moving water. By 8pm the mist had long gone, and having exposed three rolls of film, I was satisfied with an excellent morning's photography.

PLANNING

LOCATION
Derwentwater, Keswick,
Lake District, Cumbria

HOW TO GET THERE
Arriving from the south, take the
A591 up from Windermere. From
the north and east, take turnings
off the A66, signposted Keswick,
and head for the car park next to
the theatre by the lake.
Unrestricted footpaths are marked
all the way around the lake.

WHERE TO STAY
Keswick has an abundance of
B&Bs, hotels, self-catering flats.
For full listings contact the Keswick
Tourist Information Centre,
tel: +44 (0) 1768 772645, or go to
www.golakes.co.uk

WHAT TO SHOOT
The lakes are a haven for
landscape photographers; moody
mountains overlooking flat calm
lakes with perfect reflections,
coupled with an ever-changing
weather system guarantees superb
lighting conditions. Rowing boats,
launches, shoreline details,
patterns, trees.

WHAT TO TAKE
Wideangles to include foreground
interest, like the boats. Medium
format for the classic calendar
shots. A tripod is essential,
polarizer, neutral-density
graduated filters, 81 series warm-
up filters. Stout walking boots and
clothing, compass and a map.

BEST TIMES OF YEAR
Winter is awe-inspiring; fresh crisp
snow falls on the fells from the
middle of November and stays well
into February. The mountainous
landscape coupled with strong
winter light bouncing off the lake is
very dramatic. Autumn trees and
bracken cloak the shoreline in
golds and browns.

ORDNANCE SURVEY MAP
Landranger sheet 90

Elterwater

SPARKLING ELTERWATER LIES IN THE HEART OF THE LAKE DISTRICT AND PROVIDES SOME TRULY BREATHTAKING VIEWS, PERFECTLY COMPLEMENTED BY AUTUMN COLOUR **ANN & STEVE TOON**

Elterwater, and the area surrounding it, truly is the Lake District in cameo. A reed-fringed lake, bracken-covered fells and a stunning backdrop – the distant high peaks of the Langdale Pikes. Upstream, picturesque cottages cluster around a tiny green, sheltered by a sycamore. Downstream, the River Brathay meanders across gentle pastures before cascading through dense woodland to Skelwith Force.

On a bright, still September day the fells glow with early autumn colour and millpond-calm waters reflect perfect Lakeland views. Chocolate-boxy perhaps, but impossible to resist. If it's drama you're after, return on a blustery winter's day. Clamber up the slopes of

Below The clarity and stillness of this image conveys a feeling of real peace and solitude. *Canon EOS1N with 70–200mm lens, 1/60sec at f/11, Velvia 50*

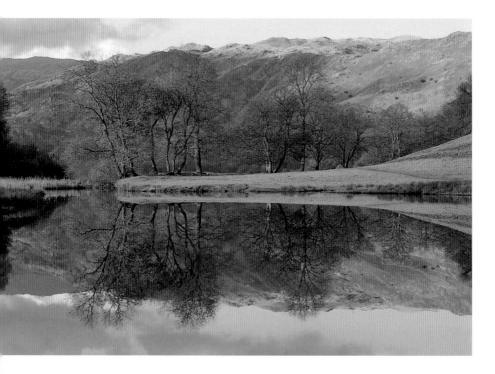

Elterwater

Elterwater was once a much larger lake, but alluvial deposits carried down from the Great and Little Langdale Valleys have created an increasingly reed-fringed and marshy lake, which one day will disappear entirely. It is one of the few lakes to be privately owned, but much of the eastern and northern shores are National Trust land. The Langdales are classic examples of glacial U-shaped valleys, while the Wrynose and Hardknott Passes between Little Langdale and the western Lake District are simply spectacular and not for the faint-hearted.

Little Loughrigg for a marvellous panorama and wait for fleeting shafts of light to burst through storm clouds and illuminate the valley floor below.

The walk from Skelwith Bridge to Elterwater village, following the River Brathay and skirting the north shore of the lake, is very popular with ramblers, not least because of the Kirkstone Galleries and tearoom at one end and the welcoming Britannia Inn at the other. This footpath offers some wonderfully photogenic views and is well worth exploring. Land on the opposite bank is not accessible to the public, which is actually a plus point

Right Keep a look out for the little details as well as the big landscapes. A hard, early frost accentuated the beautiful natural pattern of this bracken frond. *Canon EOS1N with 50mm lens, 1/15sec at f/22, Velvia 50, tripod*

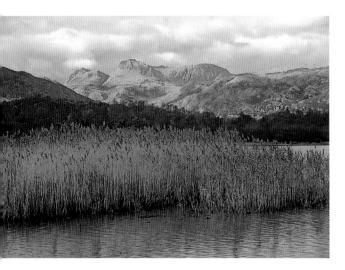

Left A standard zoom gave more depth and sense of perspective to this image of a reedbed at Elterwater, compared with the reflection shot in which a telephoto flattened the scene. *Canon EOS1N with 35–80mm lens, exposure details not recorded, Velvia 50, tripod*

Expert Advice

Elterwater derives its name from the Norse for swan, and whooper swans still overwinter here occasionally. It's a small lake, and gradually is becoming smaller still, as silt from the Little and Great Langdale valleys builds up and reeds encroach.

for photographers – you won't spend hours waiting for a crowd of flouescent cagoules to walk out of your frame – your lovely light diminishing all the time.

Given the unhelpful lack of clouds most of that day, our best shot came when, out of nowhere, cloud shadow darkened the hillside immediately behind the trees. This had the double advantage of helping to throw the trees into relief while giving some depth to the hills in the distance.

Waterfall enthusiasts could head downstream from here, to find Skelwith Force. The force is only about 20ft (6m) high, but has the greatest volume of water of any Lakeland waterfall, and turns into a raging white water torrent after rain.

Less committed souls might prefer a stroll in the opposite direction, up past the lake to the picturesque village of Elterwater. This was once an important centre for the Lake District's gunpowder industry and works remained until 1920. Today Elterwater's chief attraction is the Britannia Inn, where a pint of Jennings and a prawn sandwich make a worthy reward for a hard morning's photography.

PLANNING

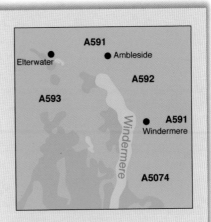

LOCATION
Elterwater lies in the heart of the Lake District, Cumbria, near the mouths of the Great and Little Langdale valleys.

HOW TO GET THERE
Take the A593 Coniston road from Ambleside, turn right on the B5343 at the Skelwith Bridge Hotel, and look for the National Trust car park. Carry on to the left turn, to get to Elterwater village.

WHERE TO STAY
In Elterwater, the Britannia offers accommodation, tel: +44 (0) 1539 437210, www.britinn.co.uk
For full listings, contact the Ambleside Tourist Information Centre, tel: +44 (0) 1539 432582 or go to www.golakes.co.uk

WHAT TO SHOOT
Autumn colours can be stunning. On still days look for reflections. Overcast conditions favour detail shots – look for fungi in the woods. Don't discount rainy weather – stormy lighting can be dramatic, if fleeting. Loughrigg Tarn, a 20-minute walk from the Silverthwaite car park, is picturesque.

WHAT TO TAKE
Your usual landscape gear and wellington boots – it can be pretty boggy around the lake and river.

BEST TIMES OF YEAR
Every season has something to offer the landscape photographer. On still, wintry days climb a little for panoramic shots, with smoke from Elterwater's cottages drifting down the valley. In summer, rise early to catch the best light and avoid the tourist hordes.

ORDNANCE SURVEY MAP
Landranger sheet 90

Contributors

ANDREAS BYRNE has written many articles for photographic magazines and supplies images to a variety of commercial, retail calendar and card companies.

ANDY LATHAM is a landscape enthusiast and regular contributor to *Outdoor Photography*. He was the winner of the *Practical Photography* Photographer of the Year award in 2004.

ANN and **STEVE TOON** are former journalists turned wildlife photographers. They contribute to photographic, natural history and travel magazines, in the UK and abroad, and have written two books.

COLIN VARNDELL is a wildlife and stock photographer whose work has featured in countless magazines and books. His love of wildlife, foxes in particular, drew him into photography from a career in construction.

CRAIG ROBERTS is a self-taught photographer and writer. He has written and supplied images for many of the major photographic magazines including *Outdoor Photography* and *Amateur Photographer*.

DAVE PORTER runs a part-time photography business whilst also working as a fireman. He regularly contributes to many photographic magazines and supplies images to the calendar, postcard and tourist board markets.

DAVID CANTRILLE is a freelance photographer who specializes in natural history. He has contributed to many books, manuals and regularly to *Outdoor Photography* magazine.

DAVID TARN is a self-taught landscape photographer who aims to create images that capture the emotion of a moment. He is the author of *Photographing Water in the Landscape* (PIP, 2004).

DEREK CROUCHER mainly spends his time shooting stock images of landscaped gardens, historic houses and travelling for various image libraries. He has contributed to many gardening and guide books.

DEREK FORSS, a professional photographer since 1979, runs his own picture library, teaches students and leads holiday tours. He contributes to all the major photographic magazines and has written three books.

GARY HACON, a retired policeman, has been a professional photographer for two years. His work has been published in *Photo Techniques* and *Outdoor Photography*.

GEOFF SIMPSON has been a full-time, professional natural-history photographer since 2000. His work is represented by Nature Picture Library, RSPB Images and Image State.

GUY EDWARDES is a professional nature and landscape photographer whose work has been widely published by national and international clients. His first book is *100 Ways to Take Better Landscape Photographs* (David & Charles, 2005).

JAMES BEATTIE has been hooked on photography for over ten years and is a Technical Writer for *Outdoor Photography* and Photography Books Editor for Photographers' Institute Press. He is the co-author of two books in the popular *PIP Expanded Guide...* series.

KAREN FRENKEL is a professional landscape photographer, writer and tutor. She runs her own greetings card business in the Peak District and has illustrated many books and magazines articles about this beautiful area.

LEE FROST is a landscape photographer and prolific writer having written several books and countless articles. He lives in Northumberland and draws much inspiration from the area.

MARK HAMBLIN is a partner in the travel company Wildshots Photographic Adventures which specializes in holidays and workshops in the Scottish Highlands and is the author of two books.

MARK HICKEN and **ROS NEWTON** were inspired to take photographs seriously as a result of a long-standing interest in wildlife, nature and the outdoors.

PAUL MIGUEL is a keen photographer who has contributed articles to magazines such as *Outdoor Photography*, *Photography Monthly*, *Countryman* and *Country Smallholding*.

RON LILLEY has been photographing the landscapes of southern England for 25 years. He particularly enjoys large format in both colour and monochrome and has contributed his work to many magazines.

ROY HAMPSON is a part-time freelance photographer whose work has been featured in many journals, photo libraries, cards and calendars. He contributes to many magazines including *Amateur Photography* and *Photographic Monthly*.

ROSS HODDINOTT, a previous winner of the BBC Young Wildlife Photographer of the Year competition, is a natural history and landscape photographer based in North Cornwall. His first book is *Digital Macro Photography* (PIP, 2006).

SIMON FRASER, a professional photographer since 1986, specializes in science, nature and environmental subjects. He regularly contributes to *Outdoor Photography* and is the author of *Xtreme Sports Photography* (Rotovision, 2004).

STEVE DAY, a professional landscape, travel and wildlife photographer, died in 2003. He was a passionate and prolific writer, contributing to many magazines and travel guides and author of *Wiltshire Moods* (Halsgrove, 2004).

STEVE GOSLING is an award winning freelance photographer who specializes in creative and contemporary landscape and nature images. A keen teacher and writer on the subject, Steve contributes regularly to the major UK magazines.

STEVE MORGAN started his photo-journalism career on a local newspaper in Hull moving on to work for the Independent. He has a long-standing relationship with Greenpeace and has travelled the world photographing environmental and news stories.

Useful Contacts

GENERAL INFORMATION ON PLACES TO VISIT AND ACCOMMODATION:

English Heritage
www.english-heritage.org.uk

National Trust
www.nationaltrust.org.uk

English Tourist Board
www.enjoyengland.com

Ordnance Survey
www.ordnancesurvey.co.uk

PHOTOGRAPHIC HOLIDAYS AND COURSES IN ENGLAND:

South-West
Silverscene Photography Workshops
www.silverscenephoto.co.uk
tel: +44 (0) 1752 604266

East
Suffolk & Norfolk In Focus
www.sunrisetuition.com
tel: +44 (0) 1502 537707

West
Wiltshire Photo Tours
www.wiltshirephototours.com

North-East
The Digital Dawn
www.thedigitaldawn.com
tel; +44 (0) 1748 821041

Central
Peak District Photography Centre
www.peakphotocentre.com
tel: +44 (0) 1298 687211

North-West
Lakeland Photographic Holidays
www.lakelandphotohols.com
tel: +44 (0) 1768 778459